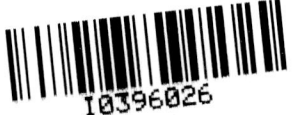

Photos

Photos by Steven Townsend

Photos of Bear Mountain, New York; Vermont; Washington, DC; and others

All photos copyright Steven Townsend

Bear

Mountain

Rowboat on Hessian Lake

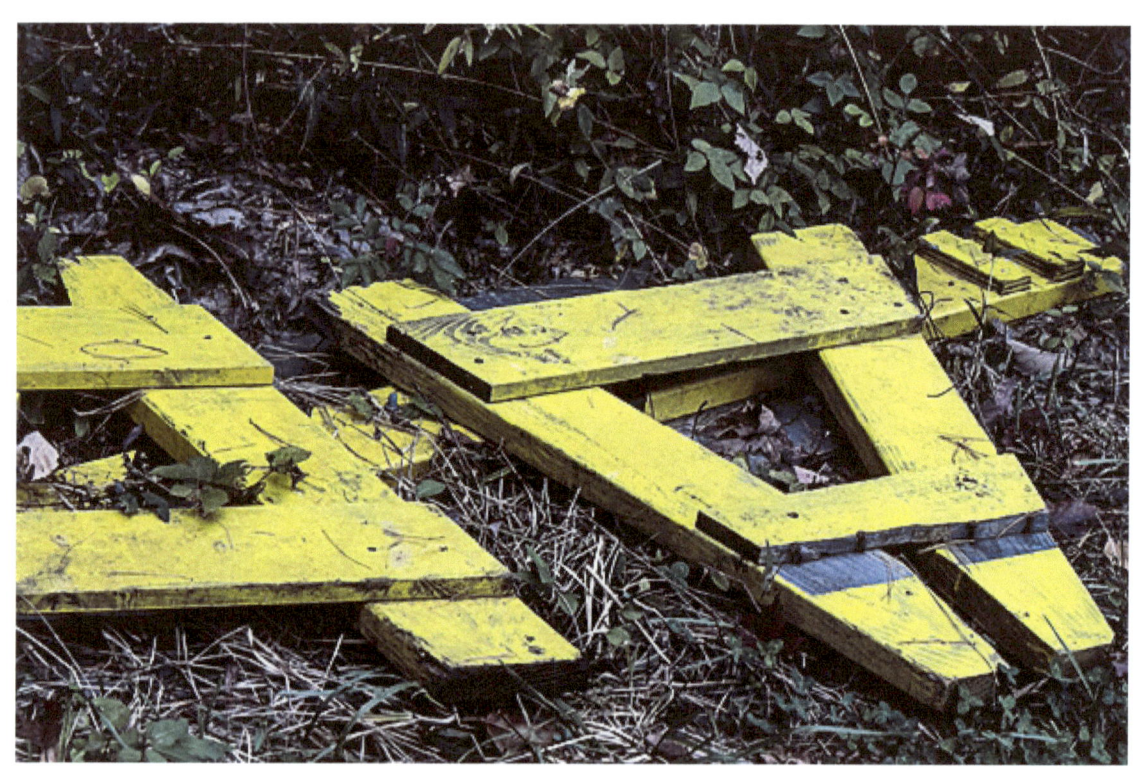

Upside Down

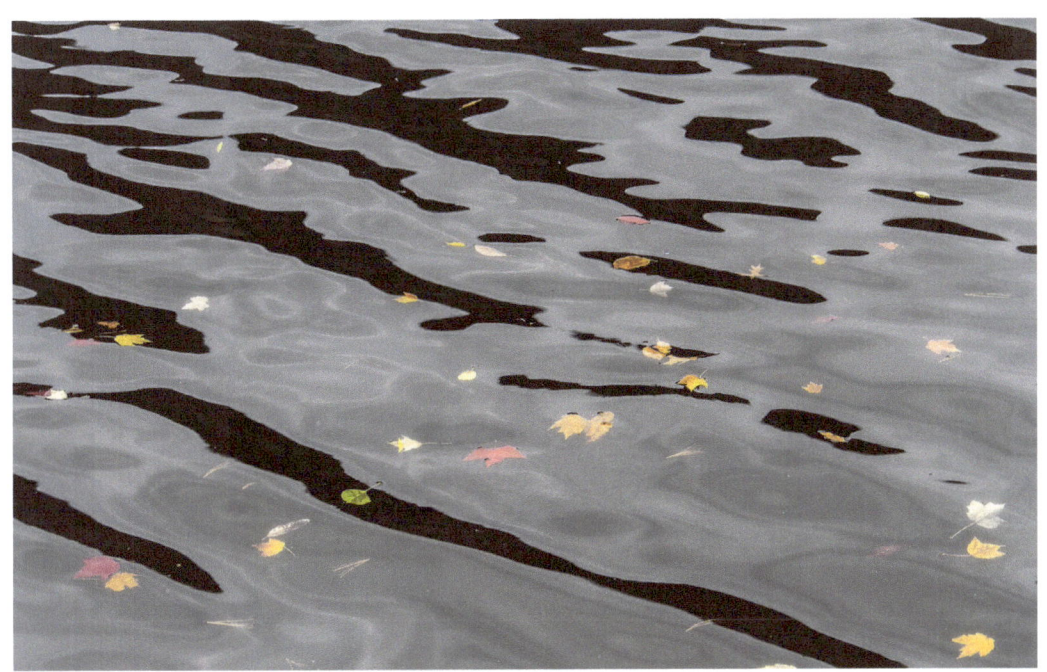

Autumn Leaves on Hessian Lake

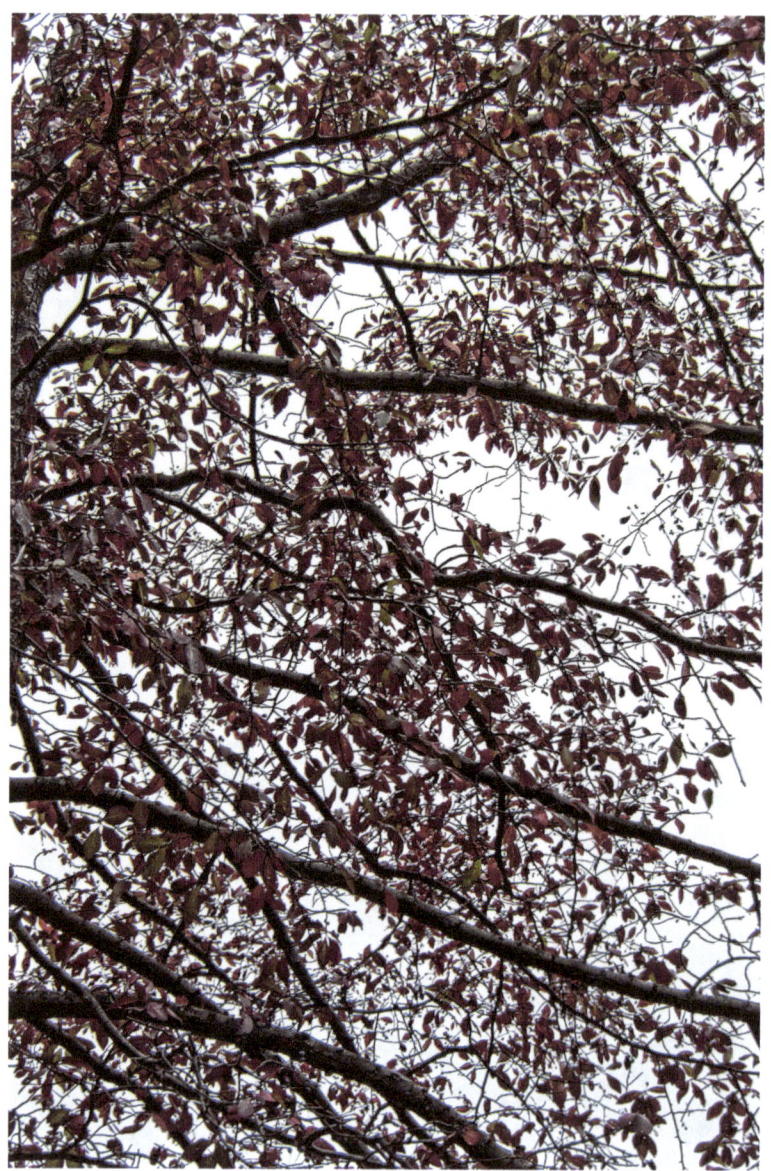

Autumn Leaves

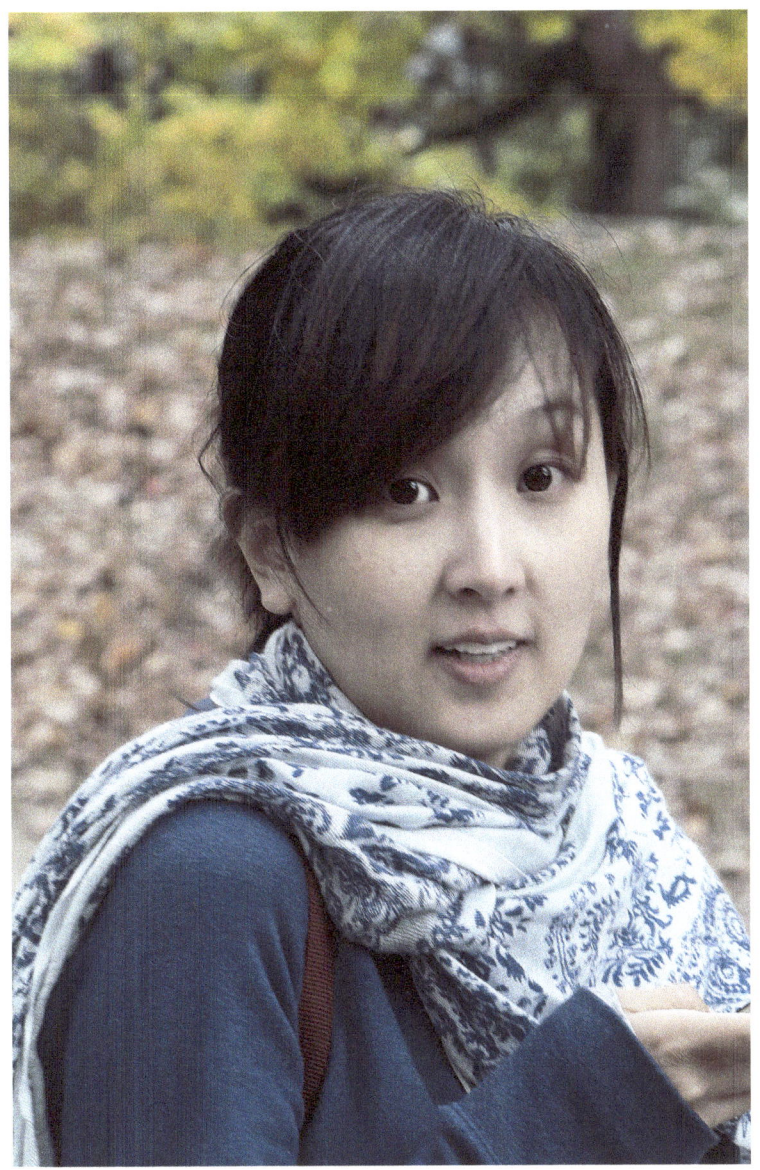
Lulu

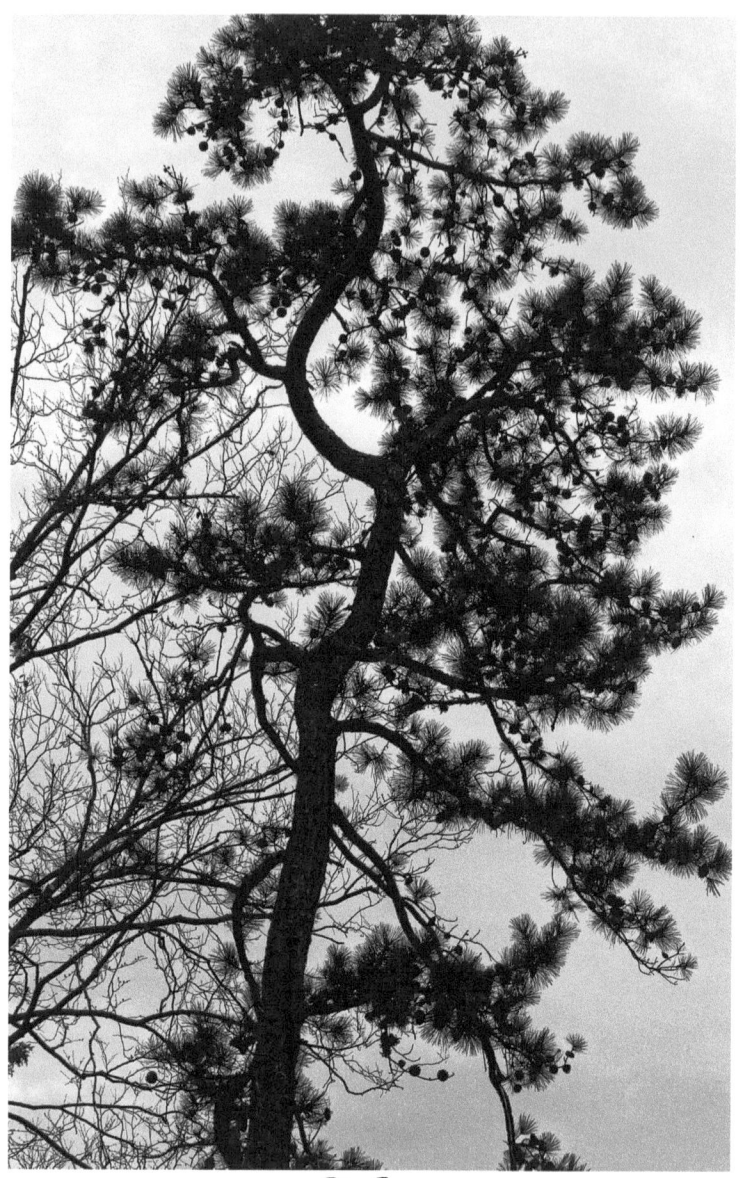

Pine Tree

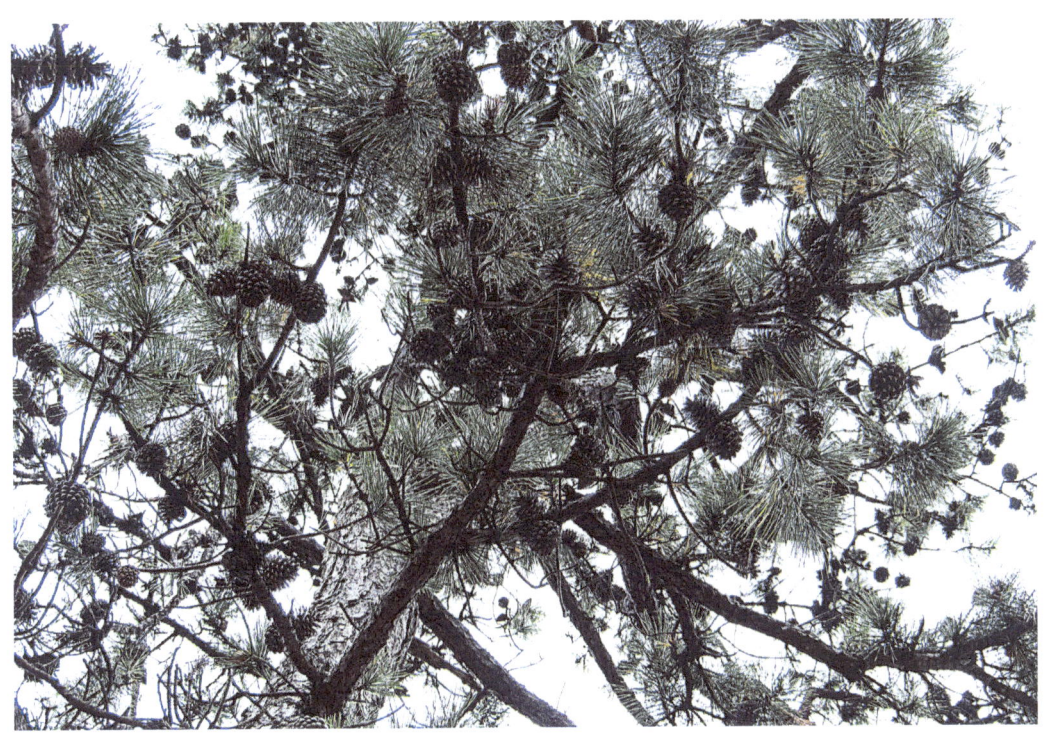

Pine Branches

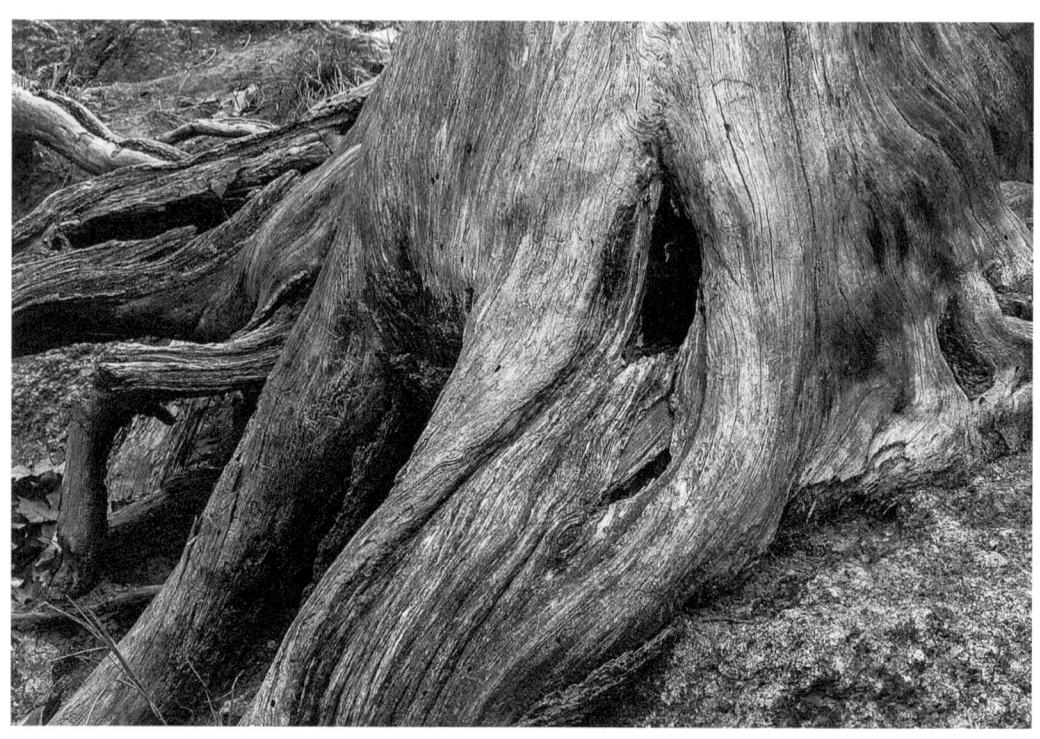

Tree Roots

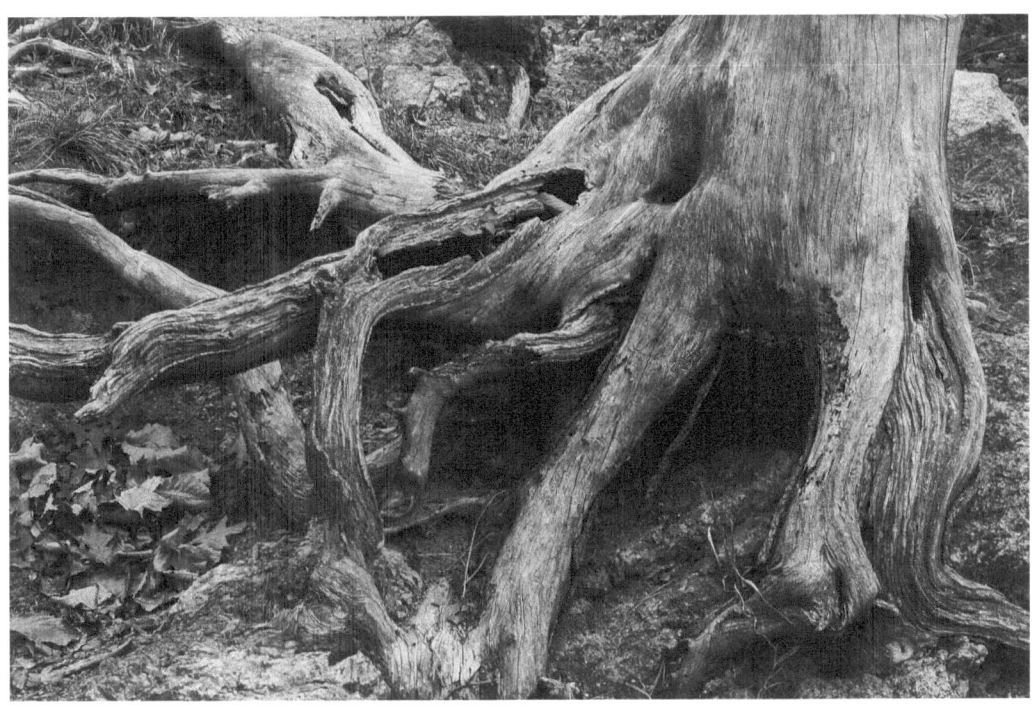

Tree Roots

Mount

Vernon

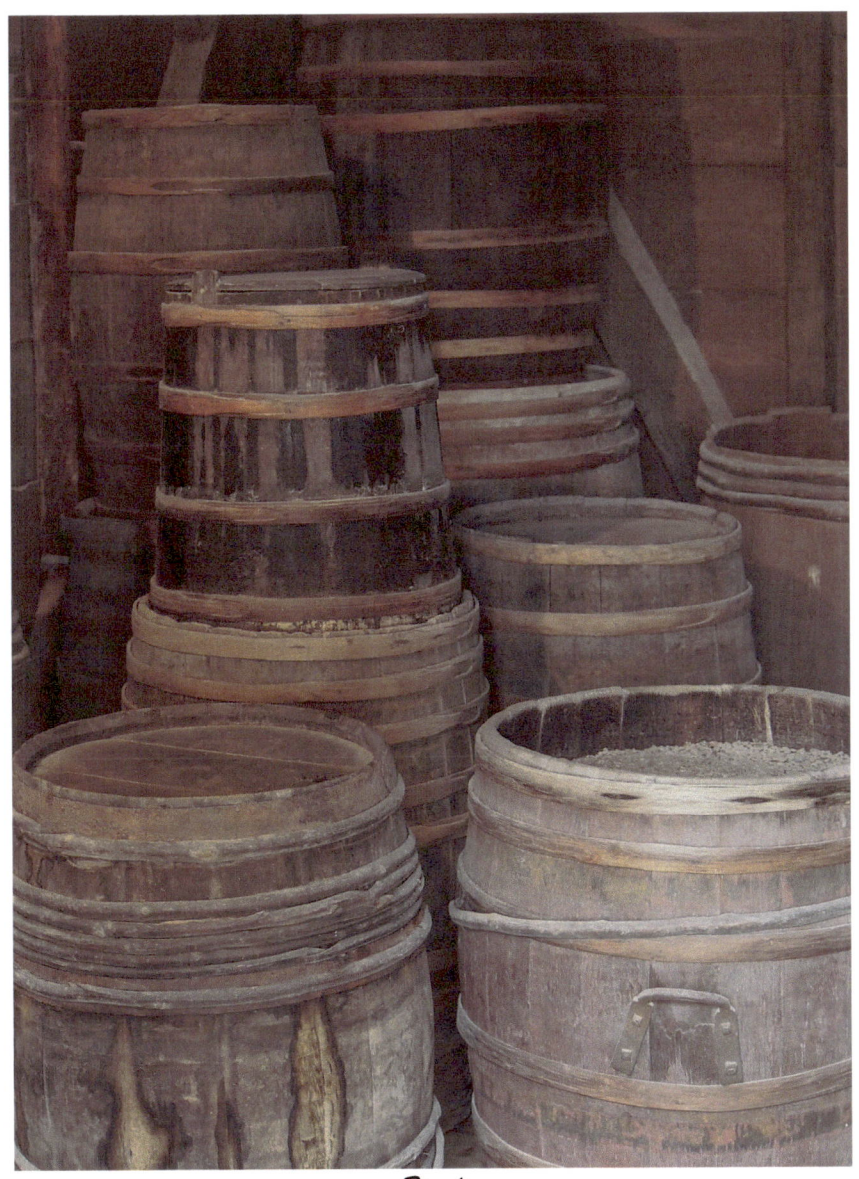

Barrels

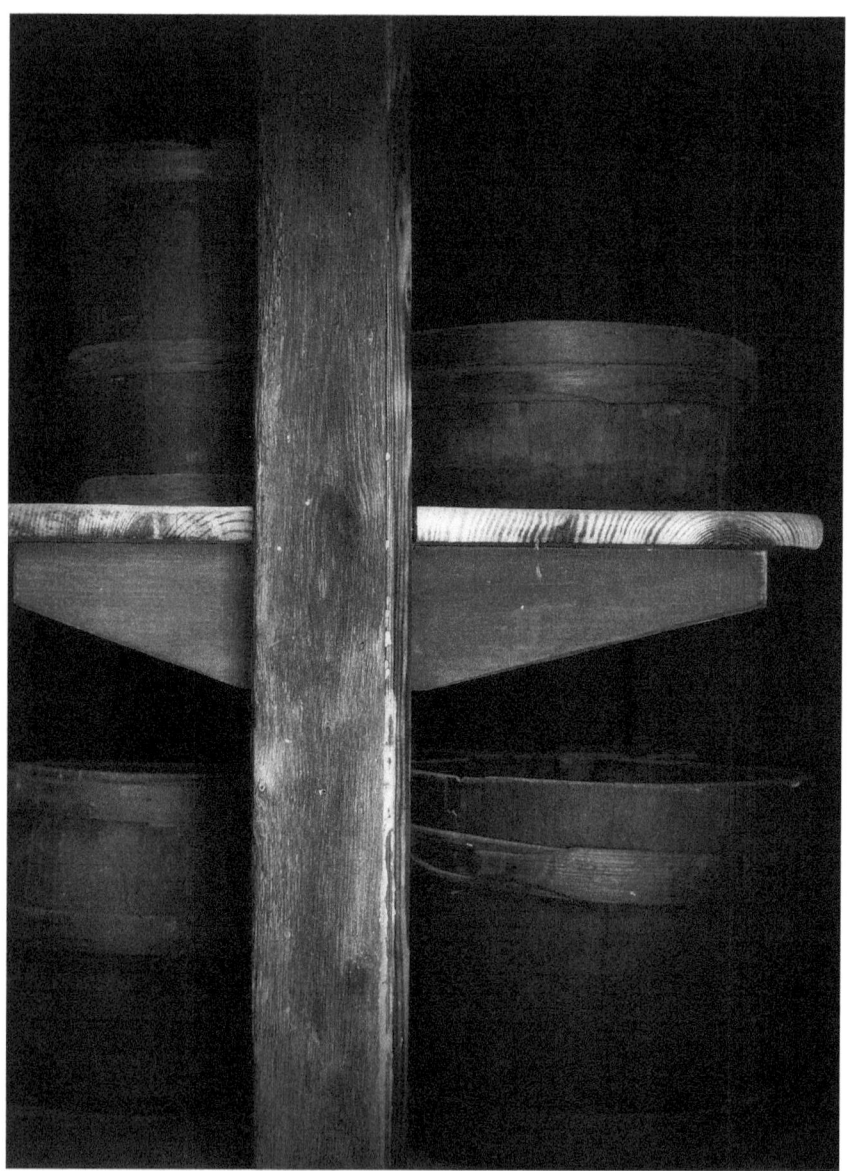
Buckets

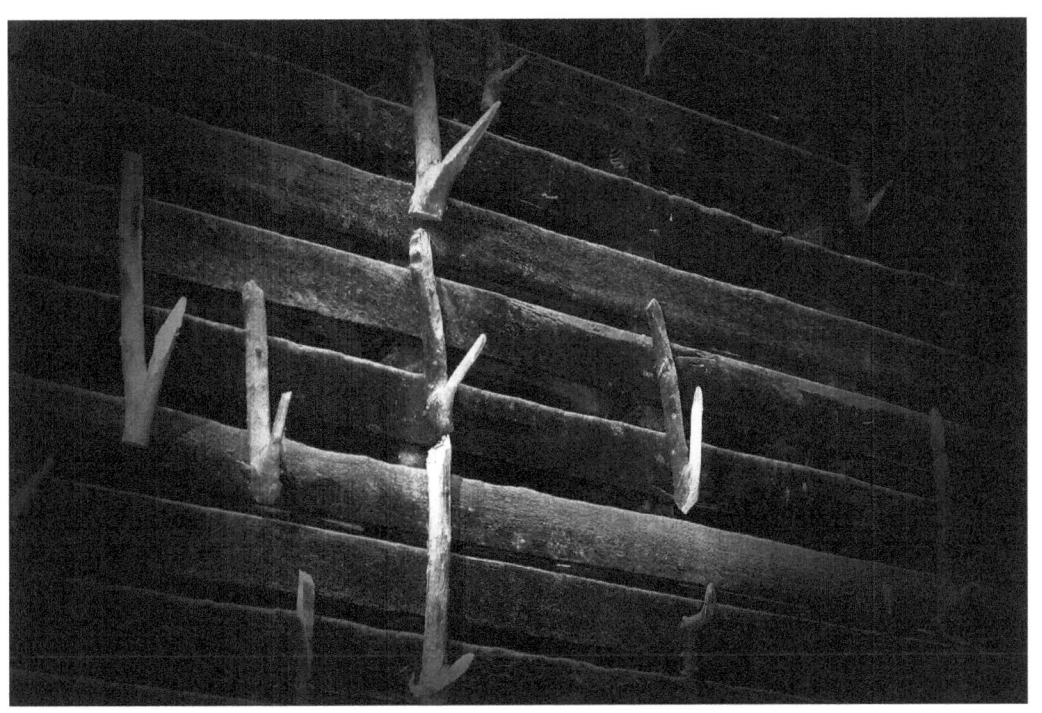

Hooks

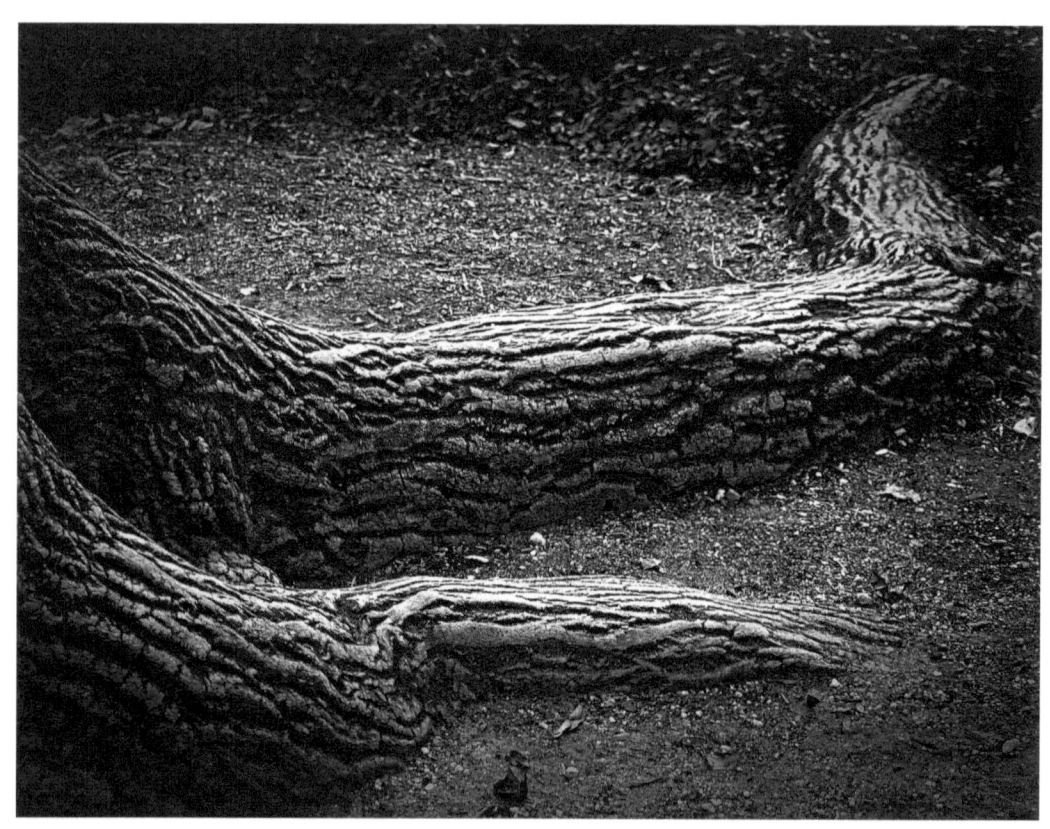

Tree Roots

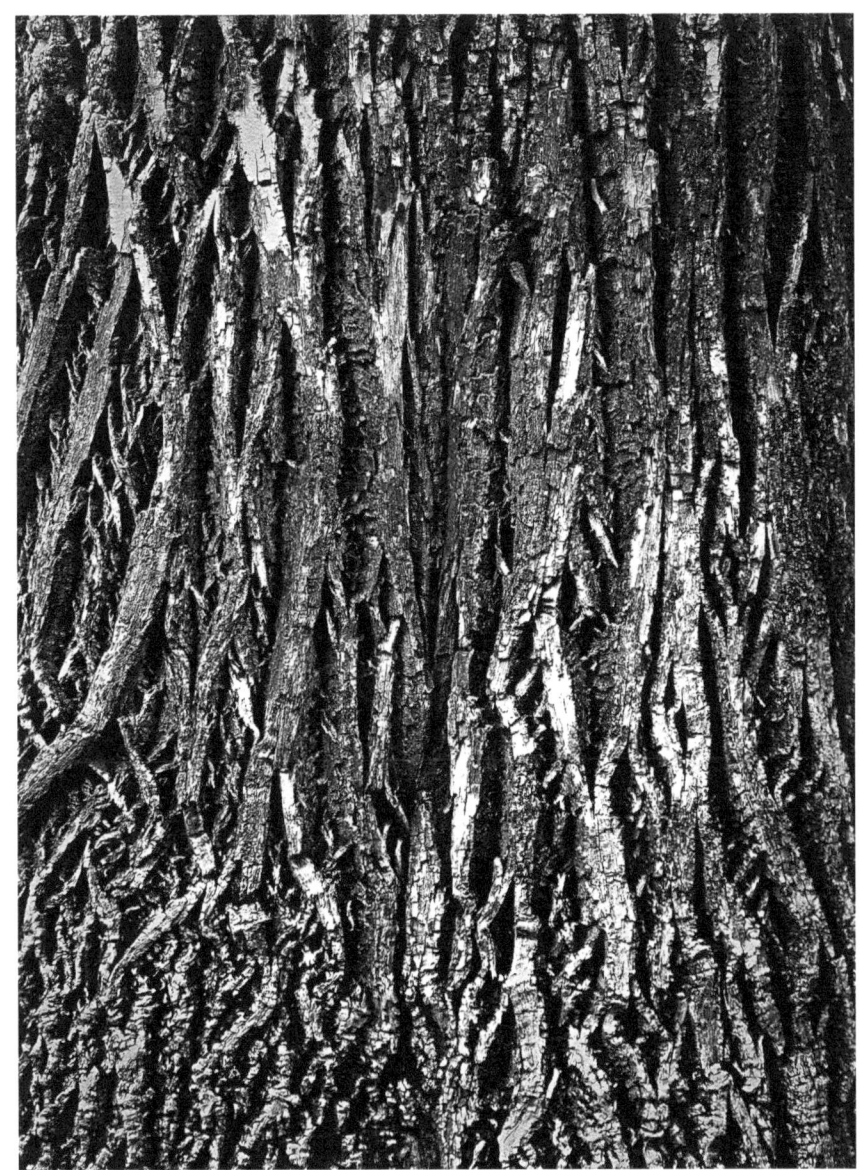
Tree Trunk

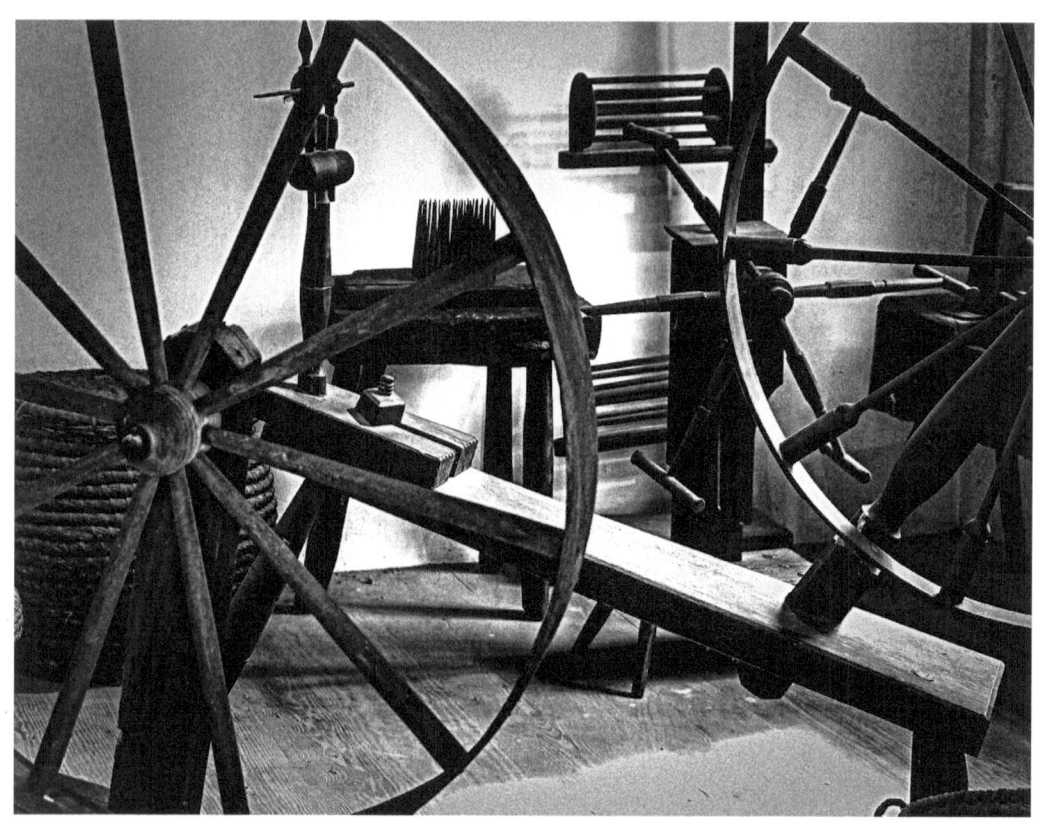

Spinning Wheels

Kenilworth Gardens

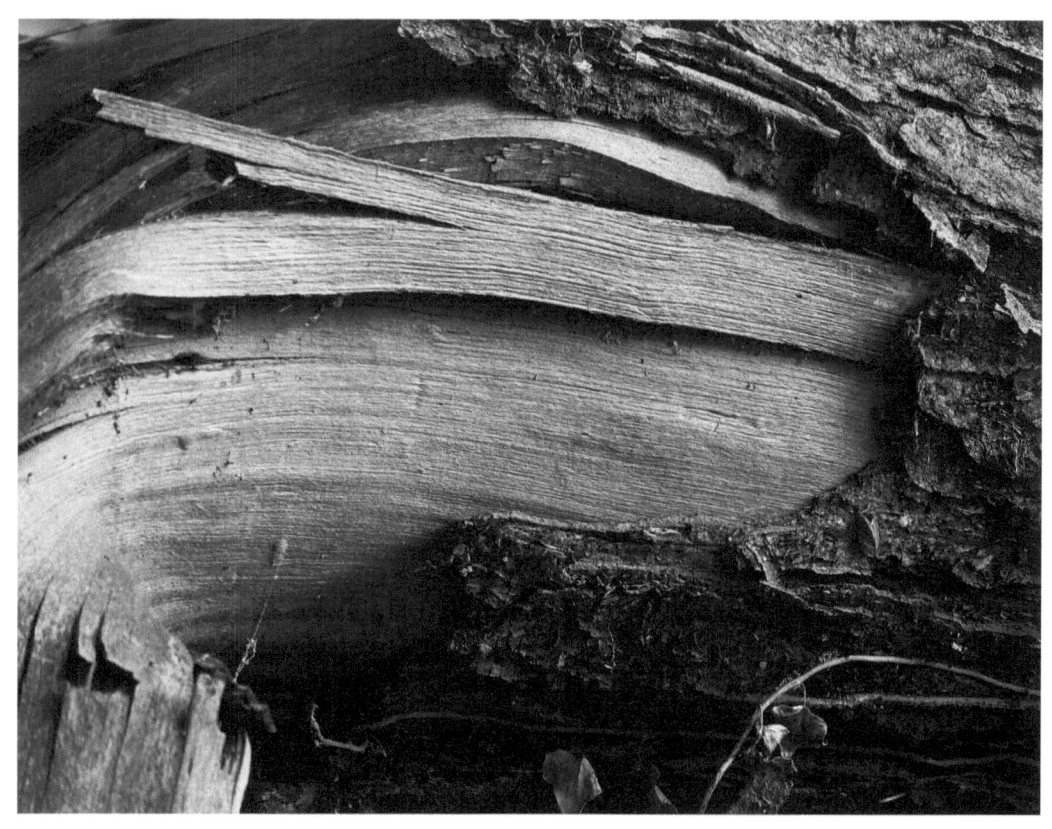

Broken Branch

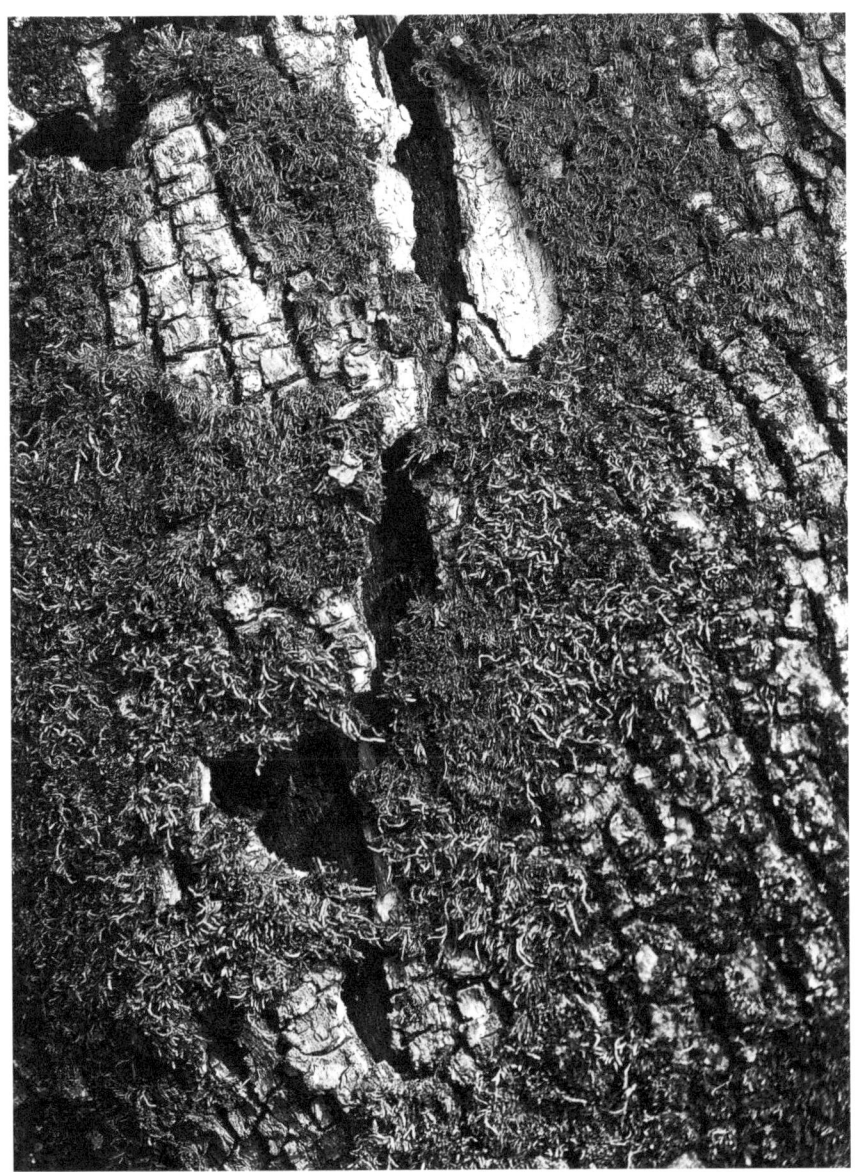

Tree Trunk

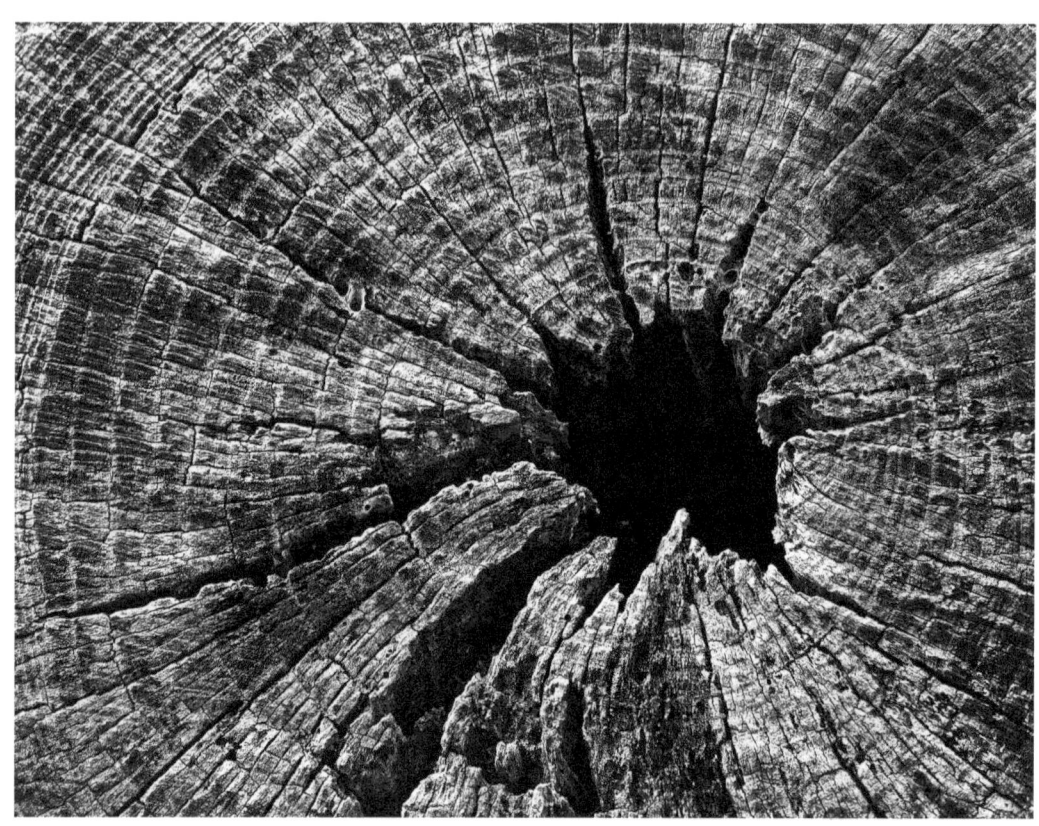

Tree Trunk

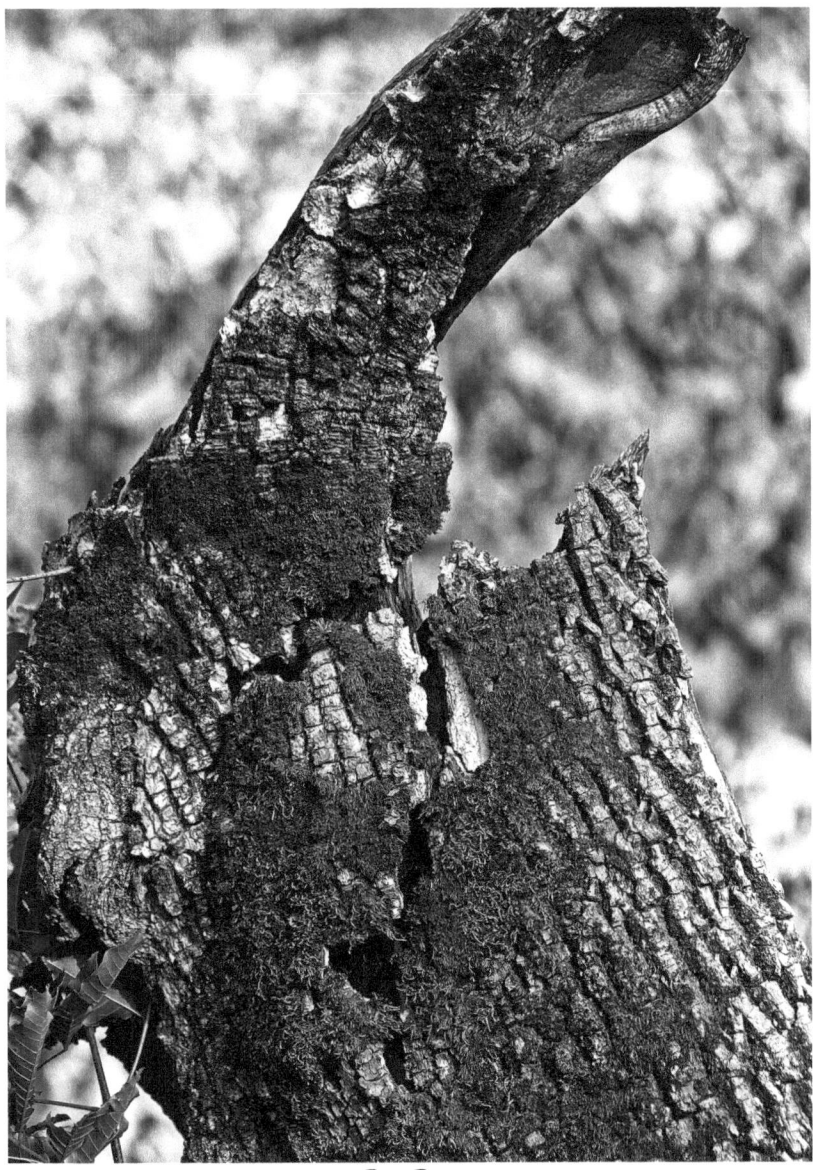

Tree Trunk

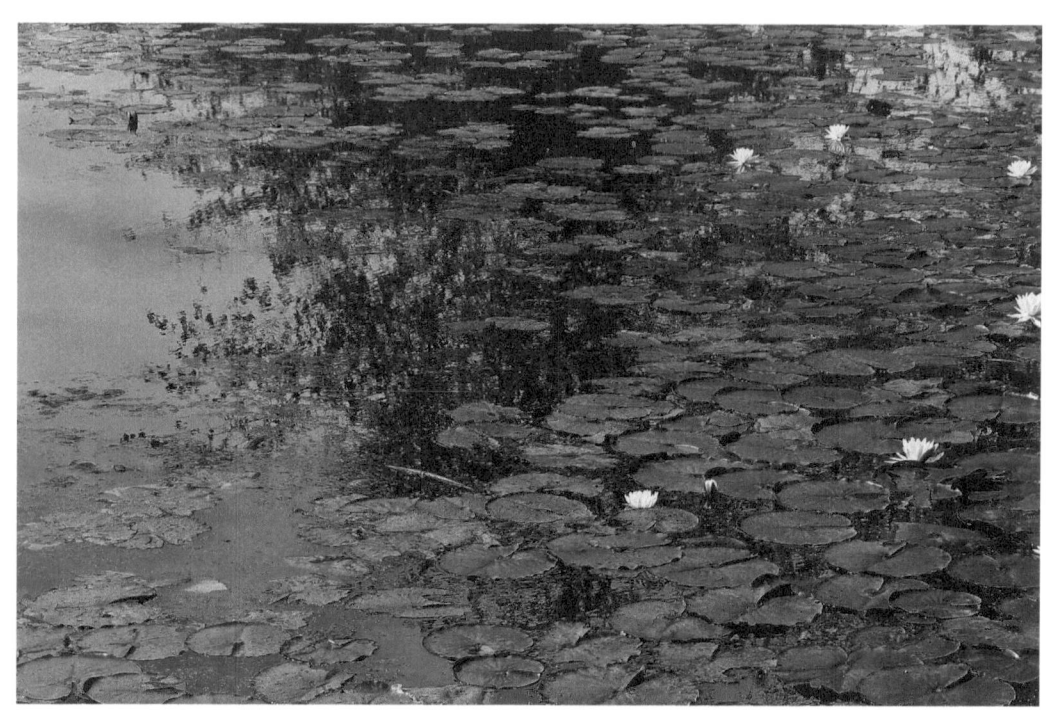

Lily Pond

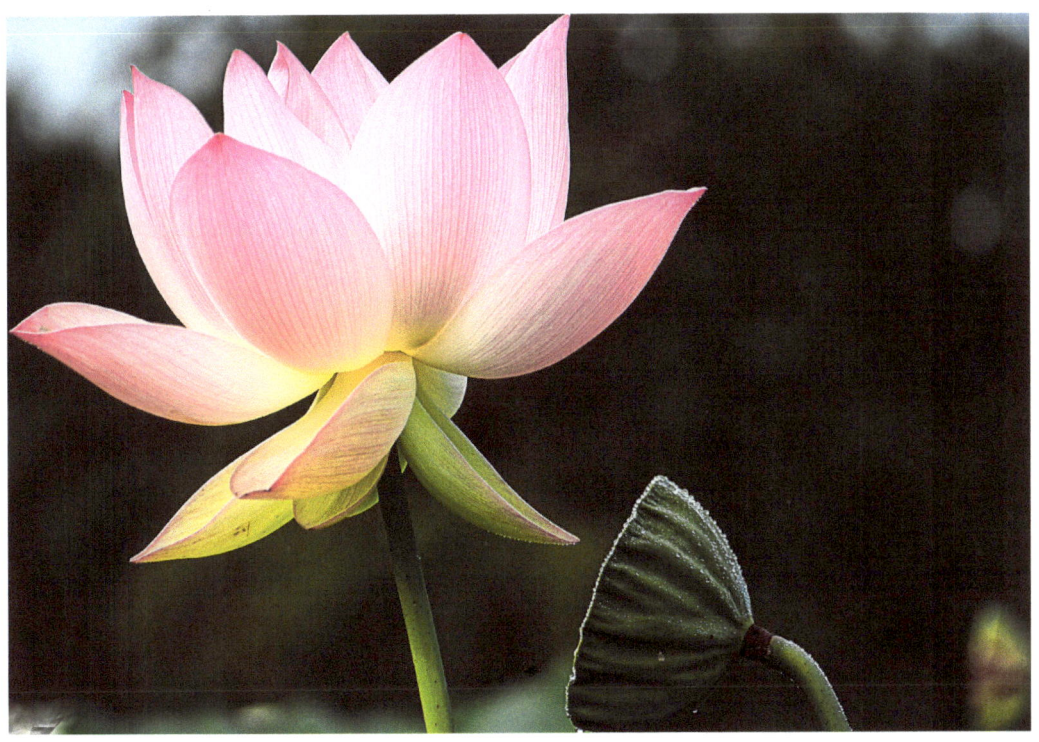

Lotus

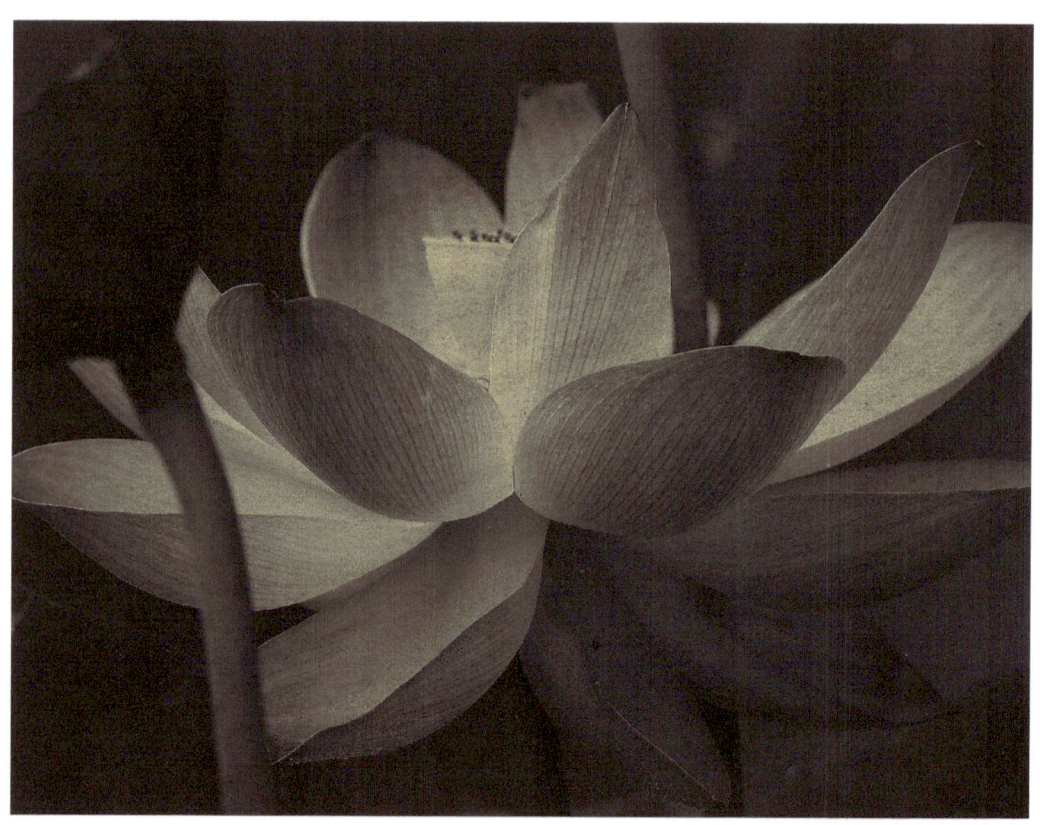

Lotus

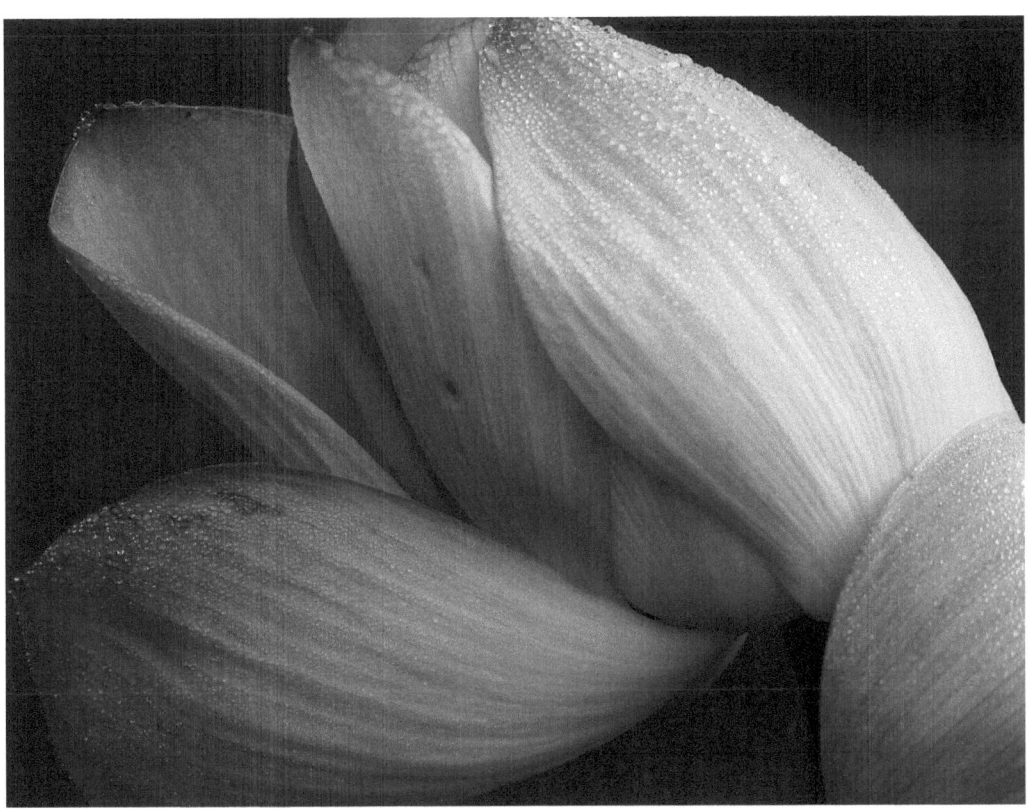

Lotus

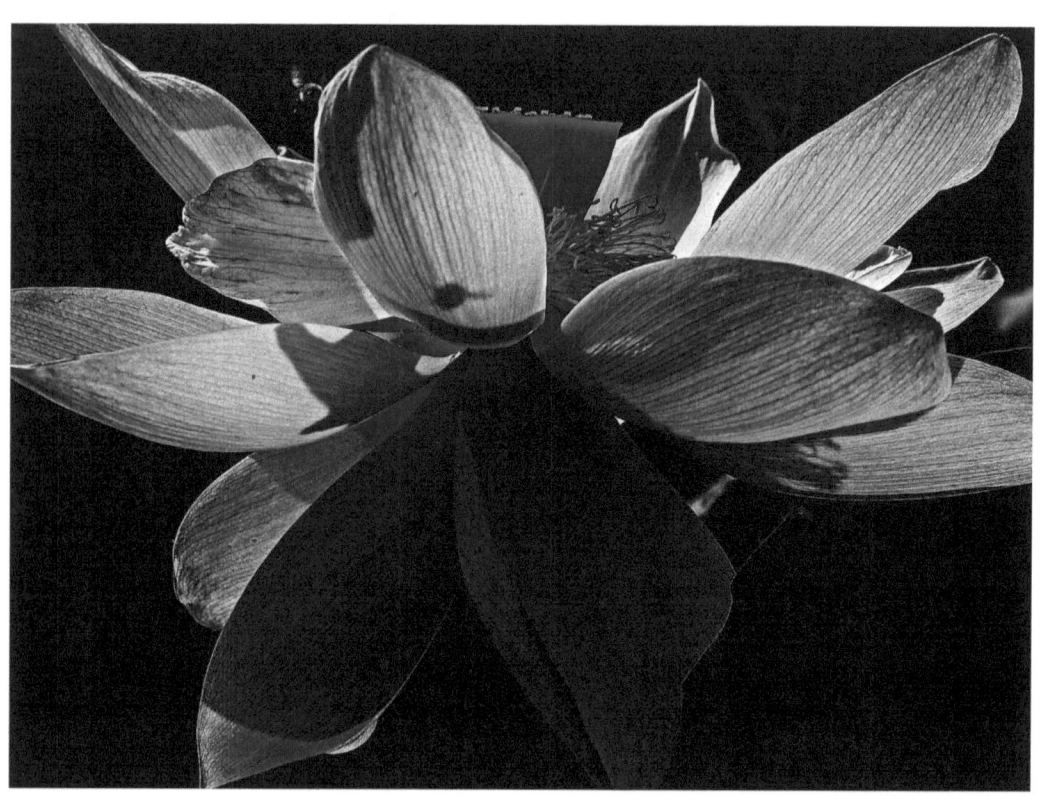

Lotus

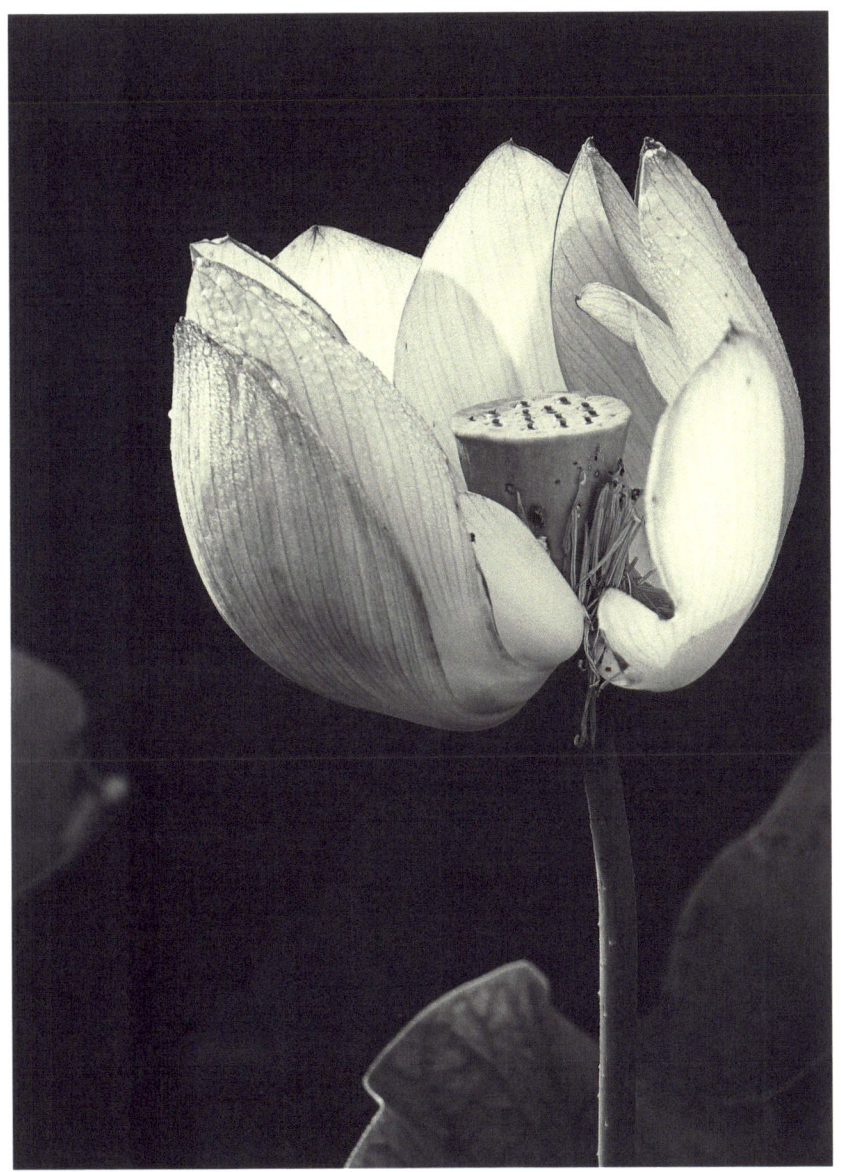
Lotus

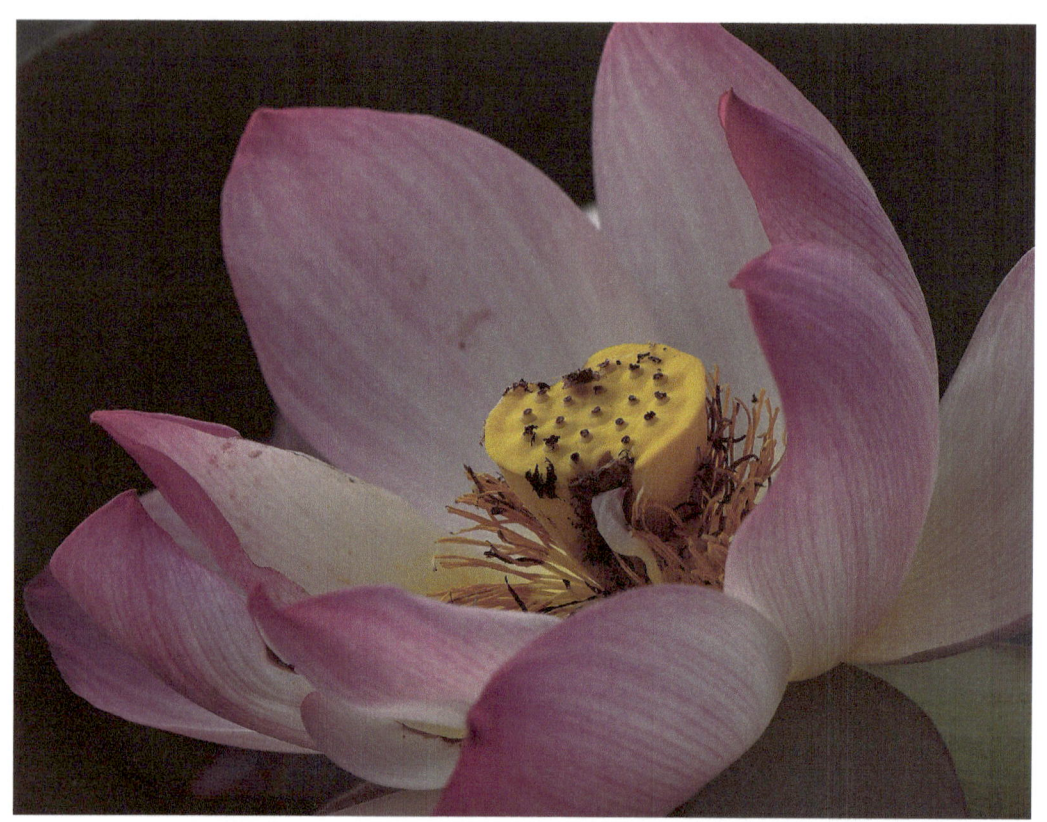

Lotus

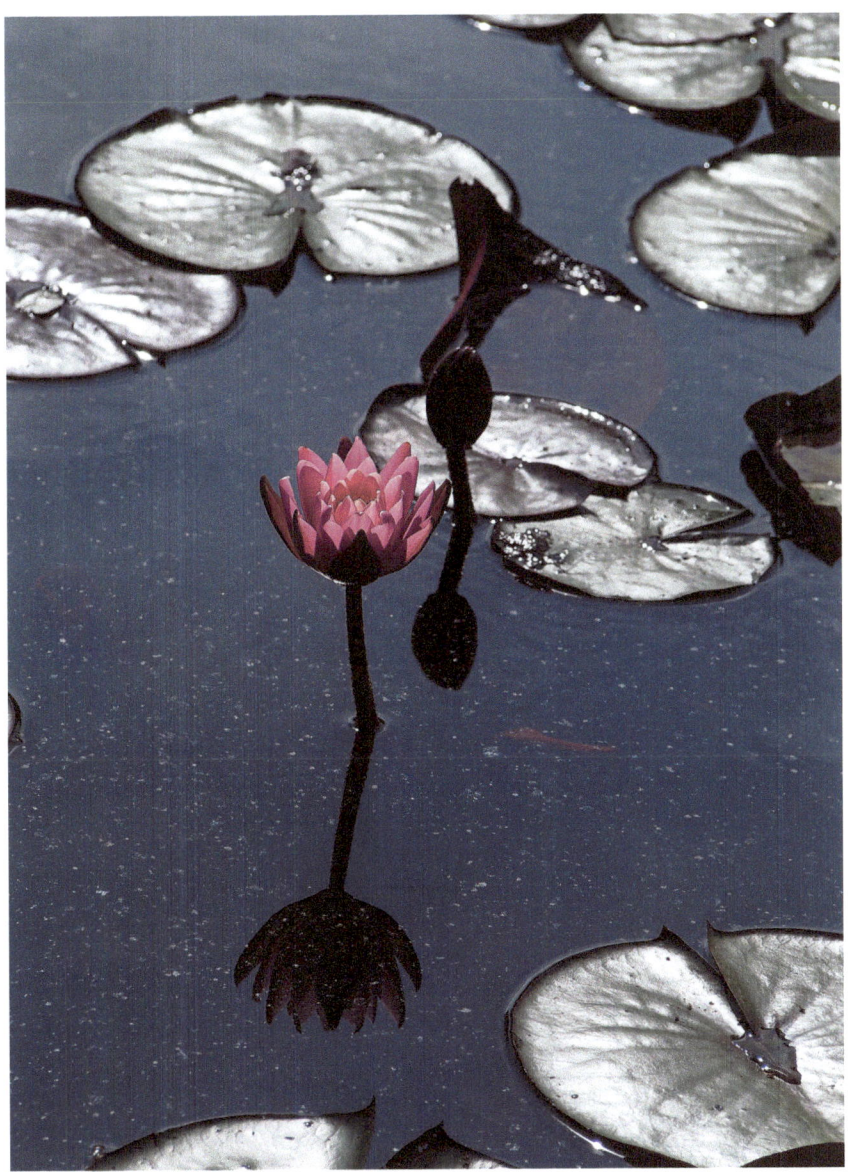

Water lily

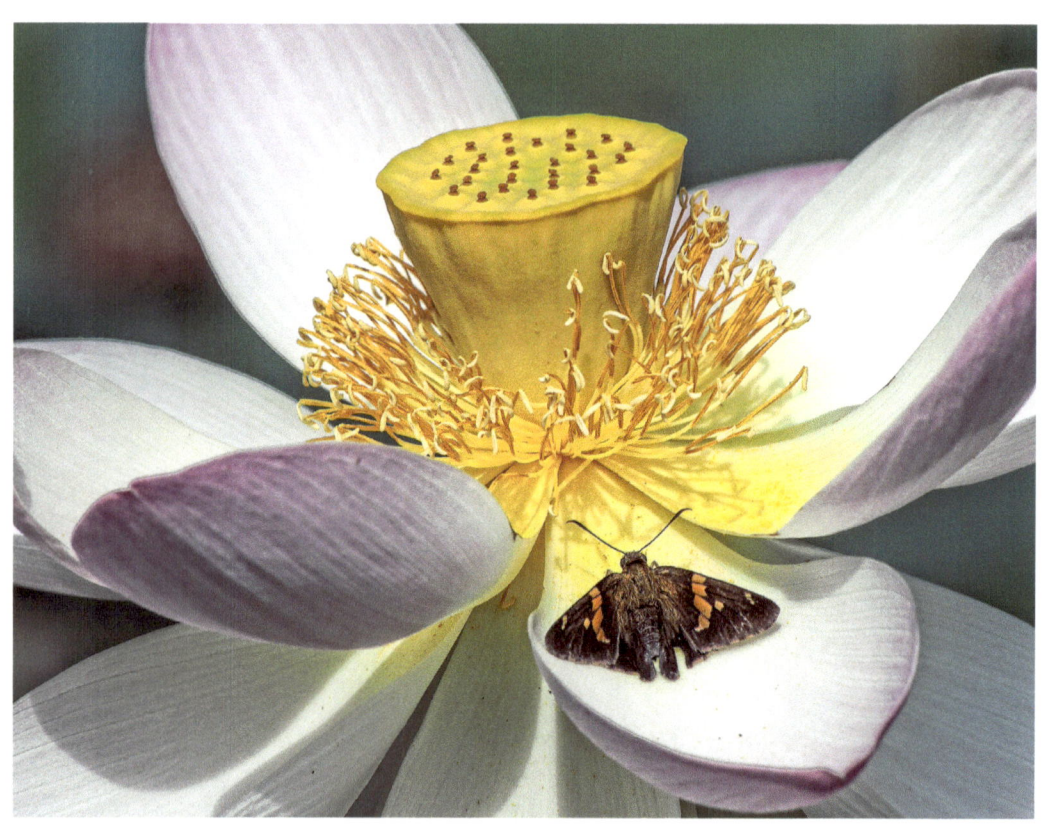

Lotus and Moth

Vermont

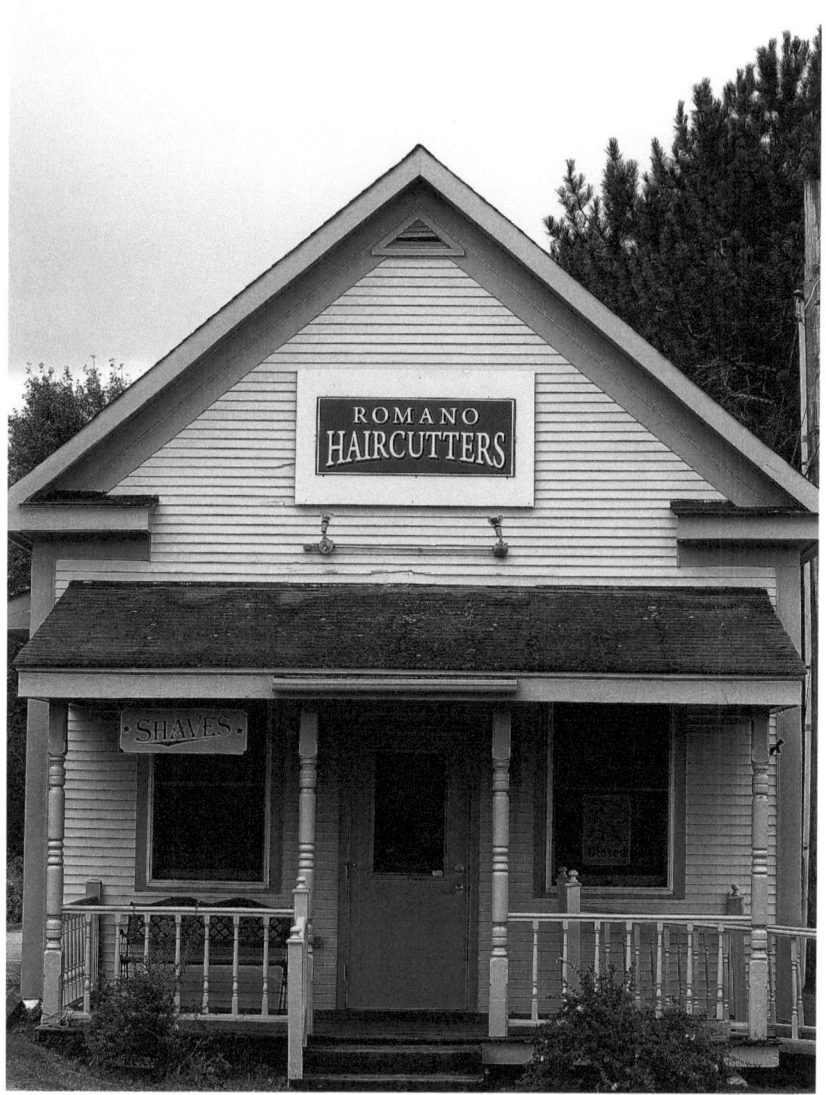

Barber, Stowe Vermont

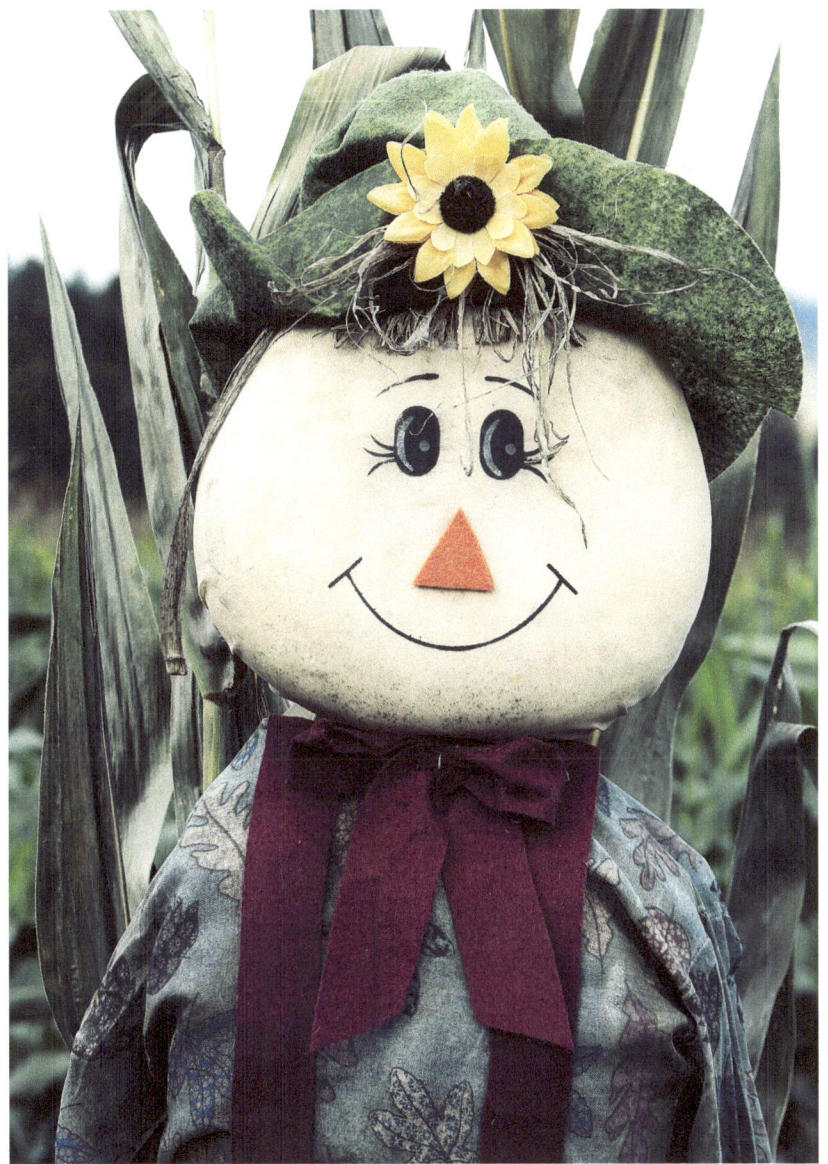
Scarecrow, Stowe Vermont

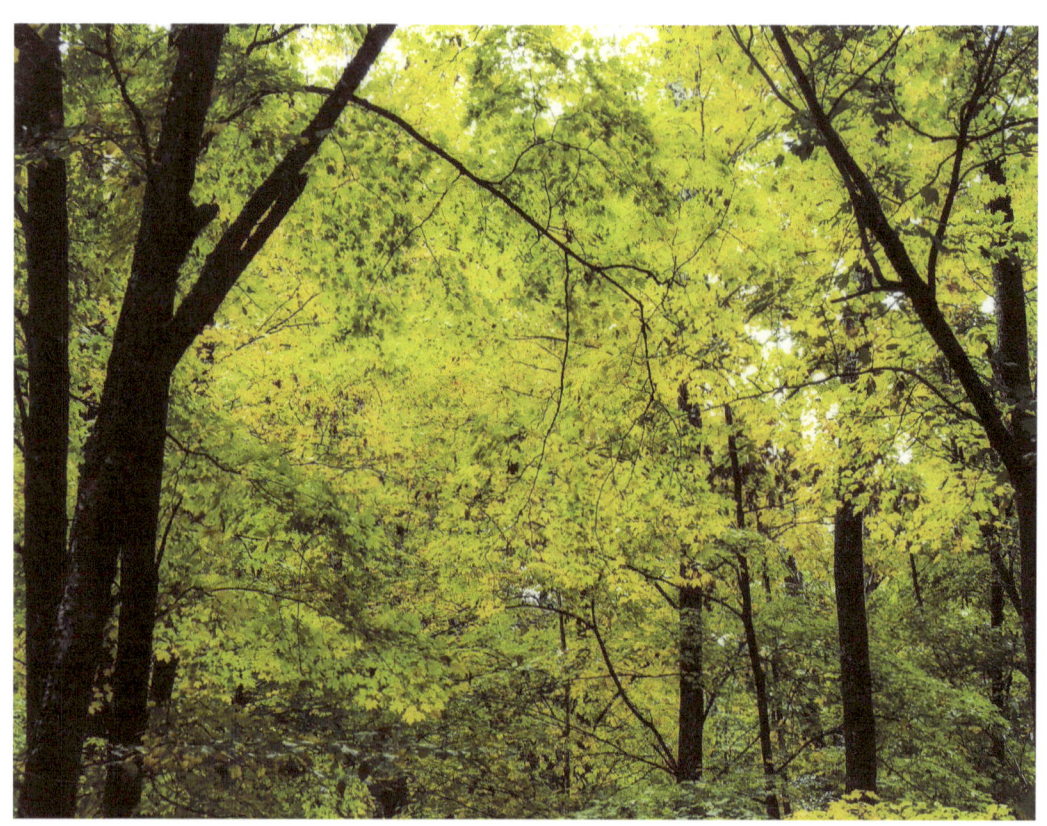

Autumn Leaves

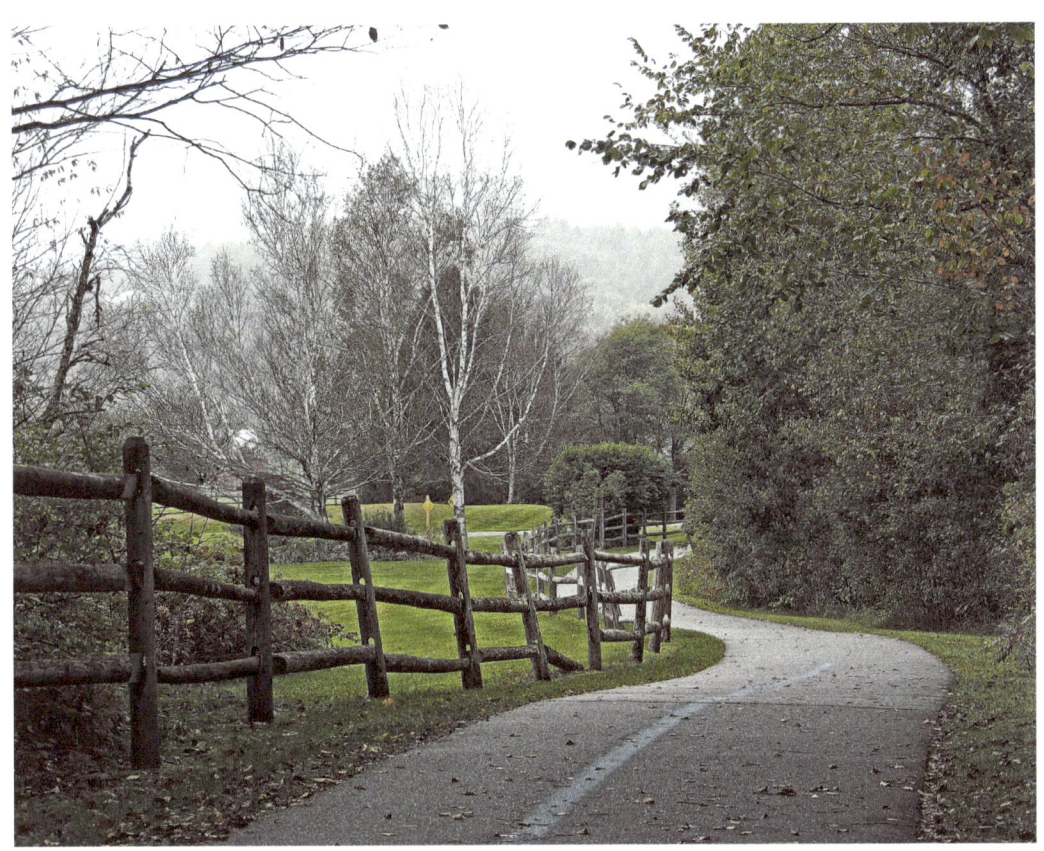

Wooden Fence

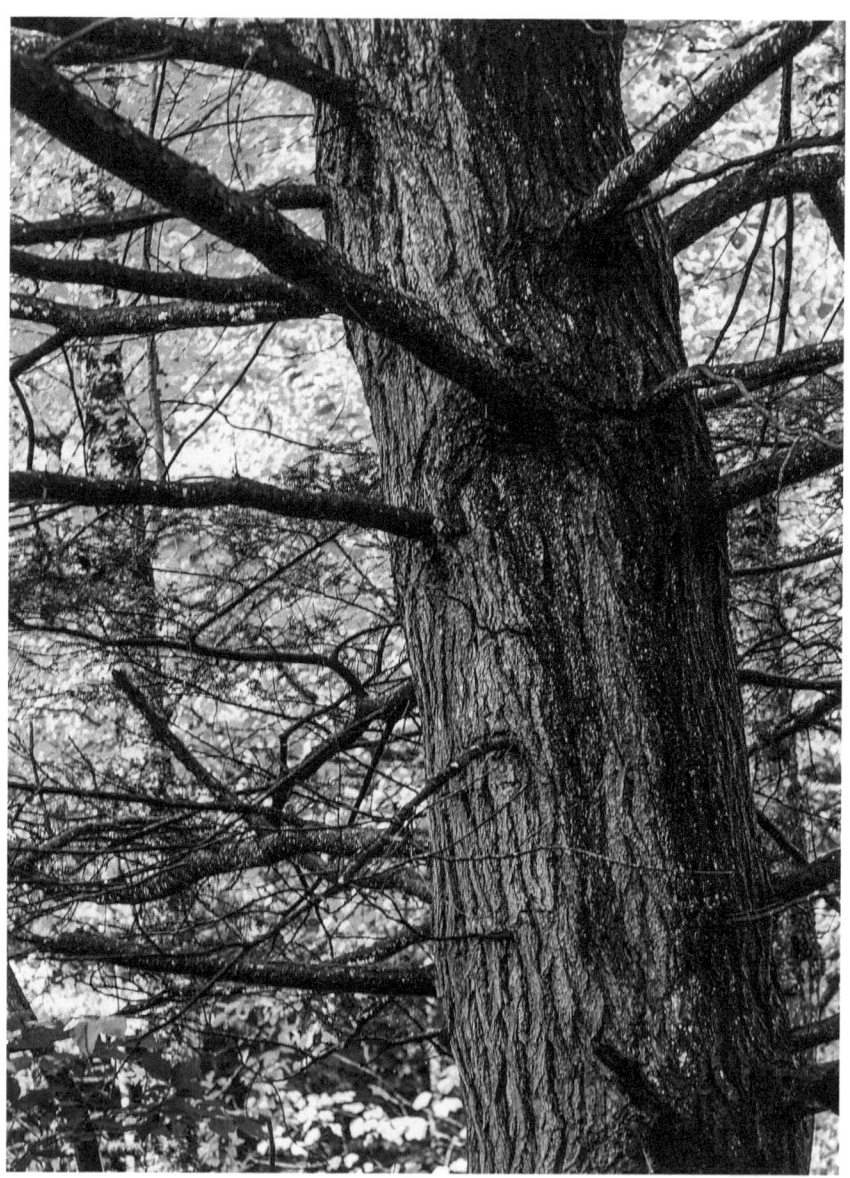
Tree

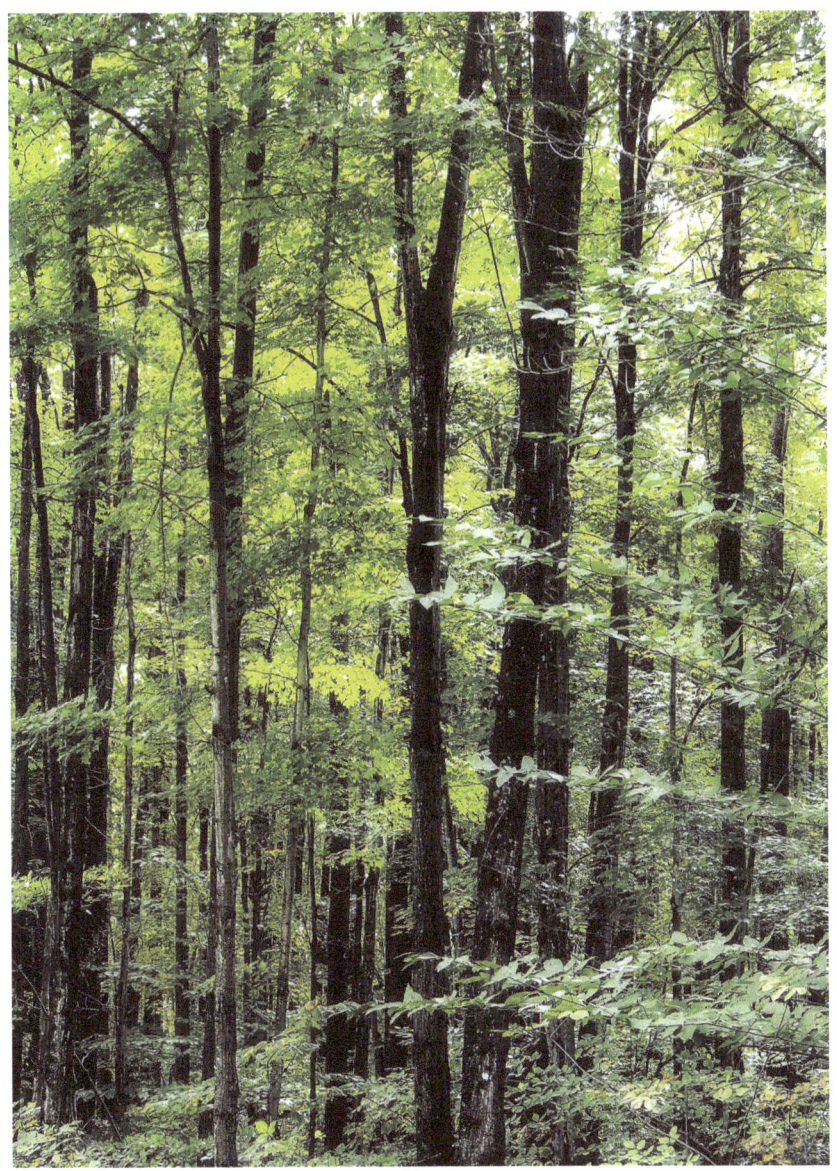
Trees

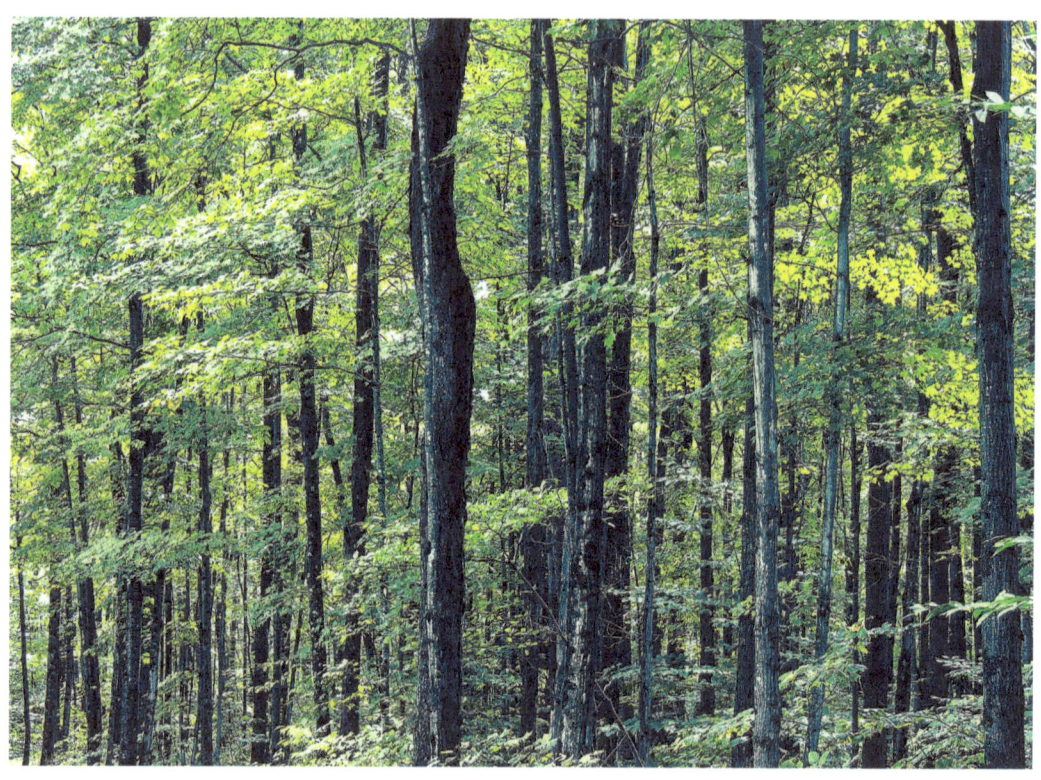

Trees

Trees

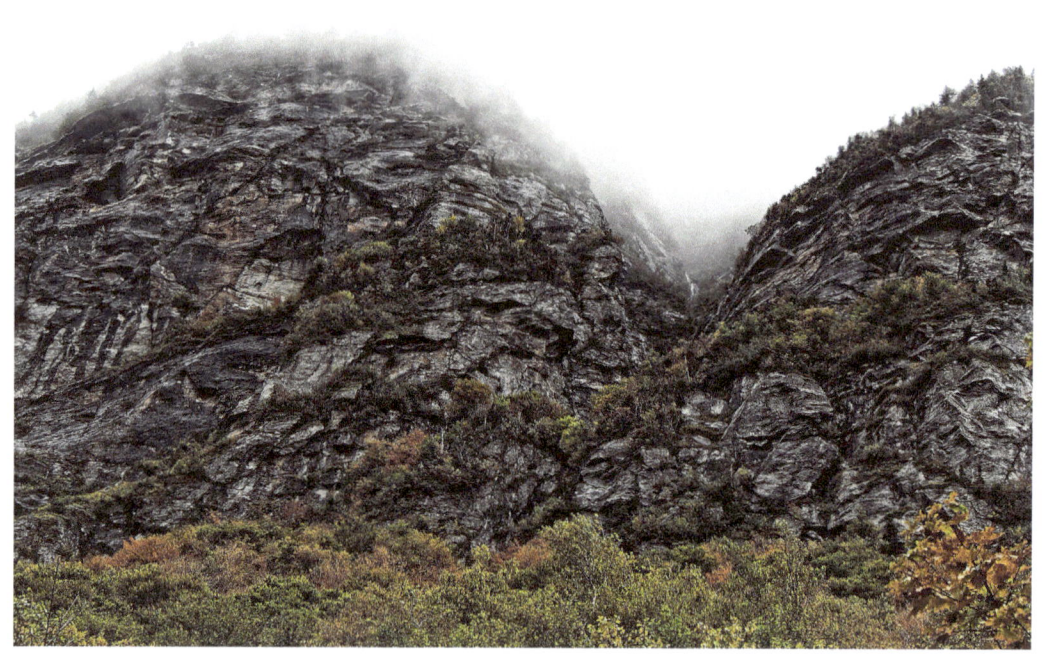

Hills

The Valley

National Botanic Garden

Abstract

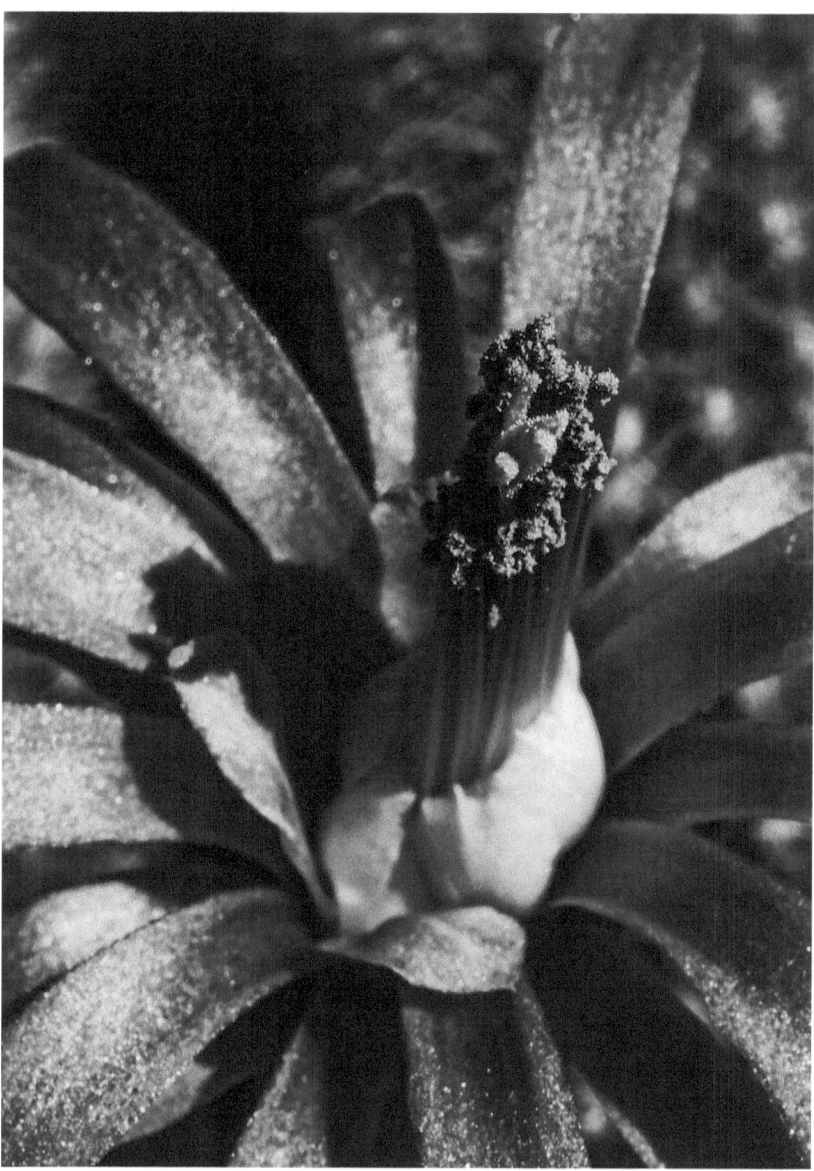

Cactus Flower

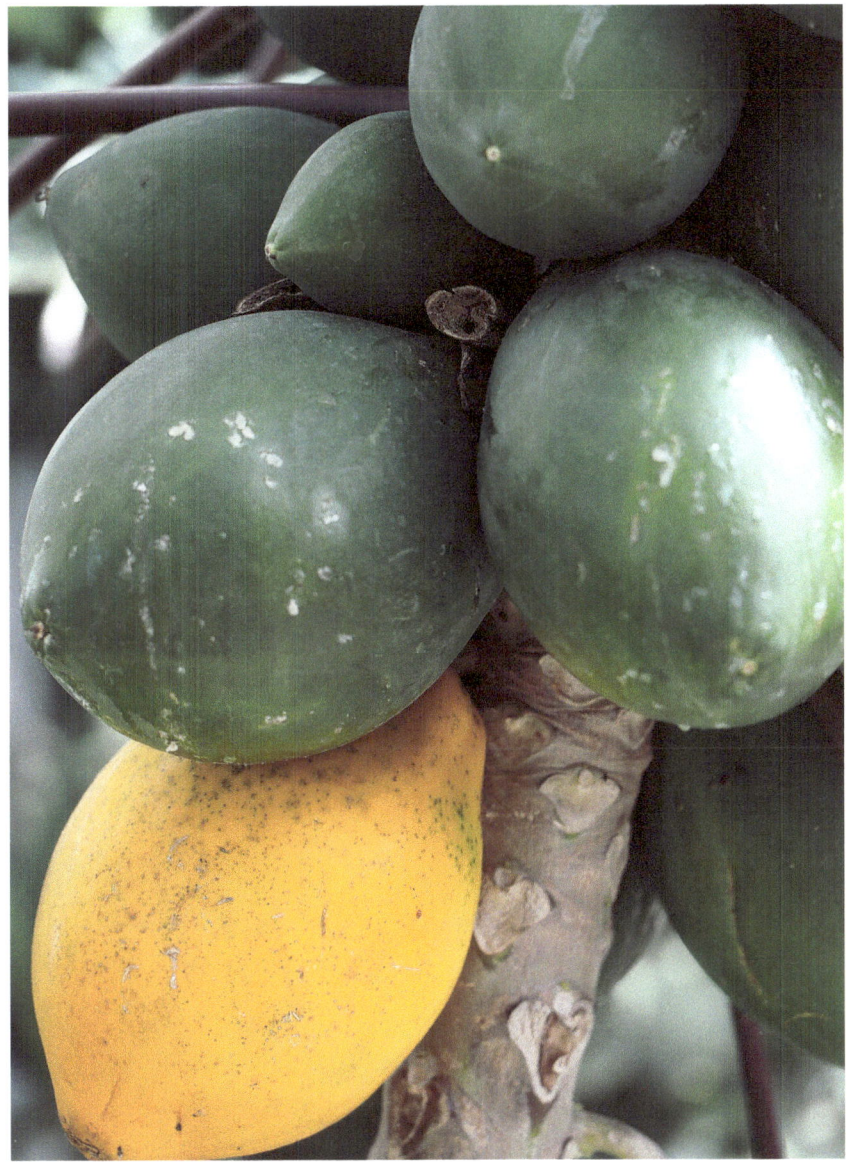
Fruit

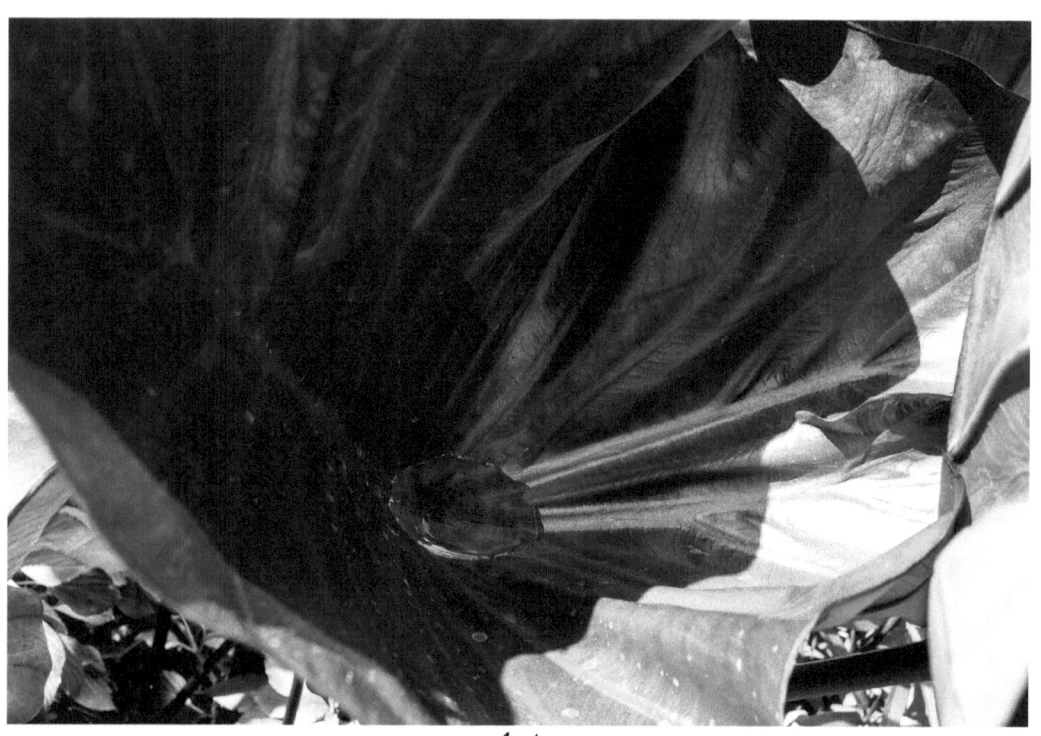
Leaf

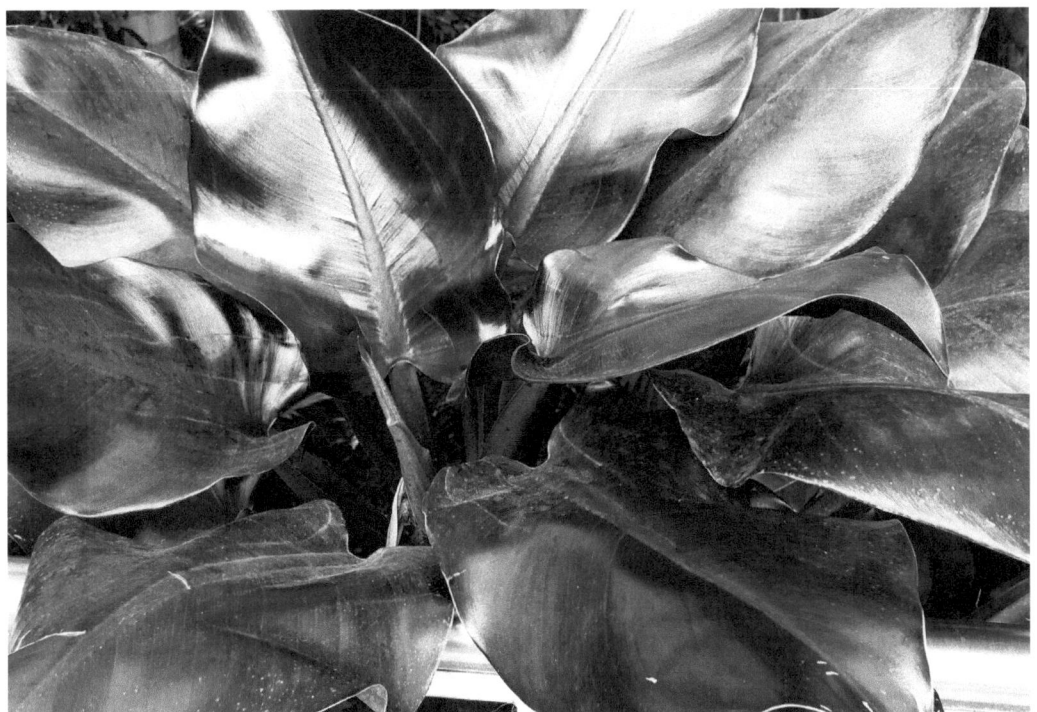

Leaves

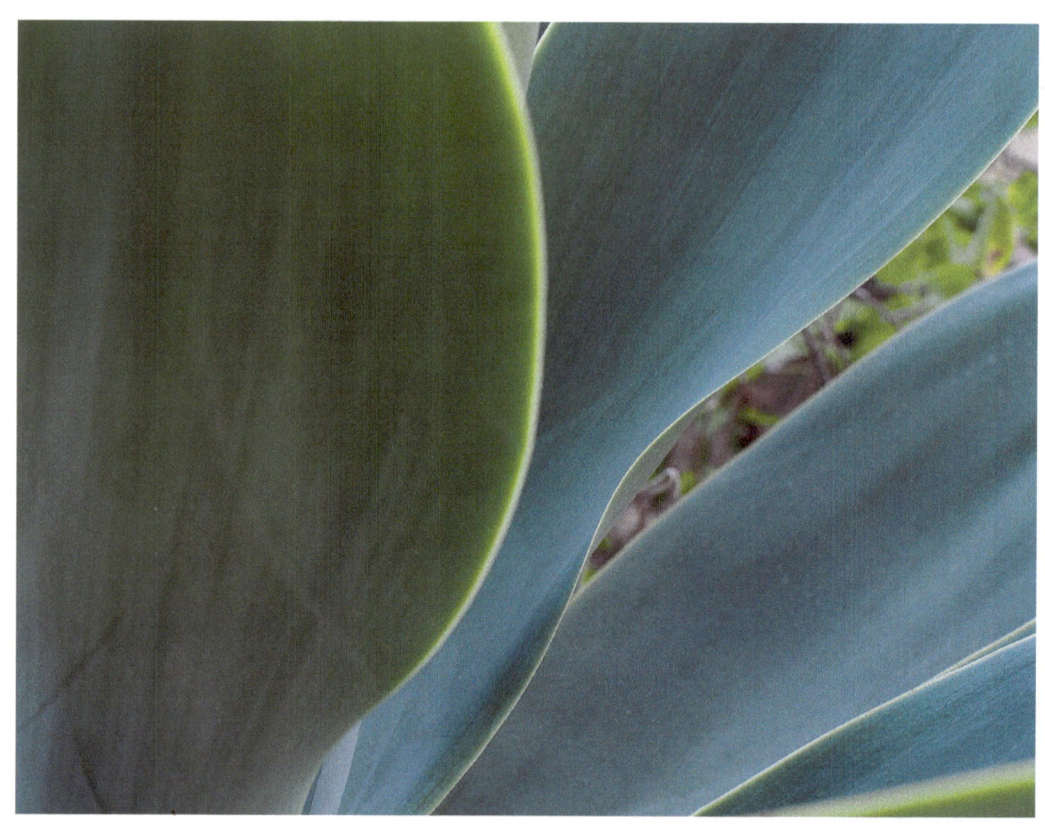

Leaves

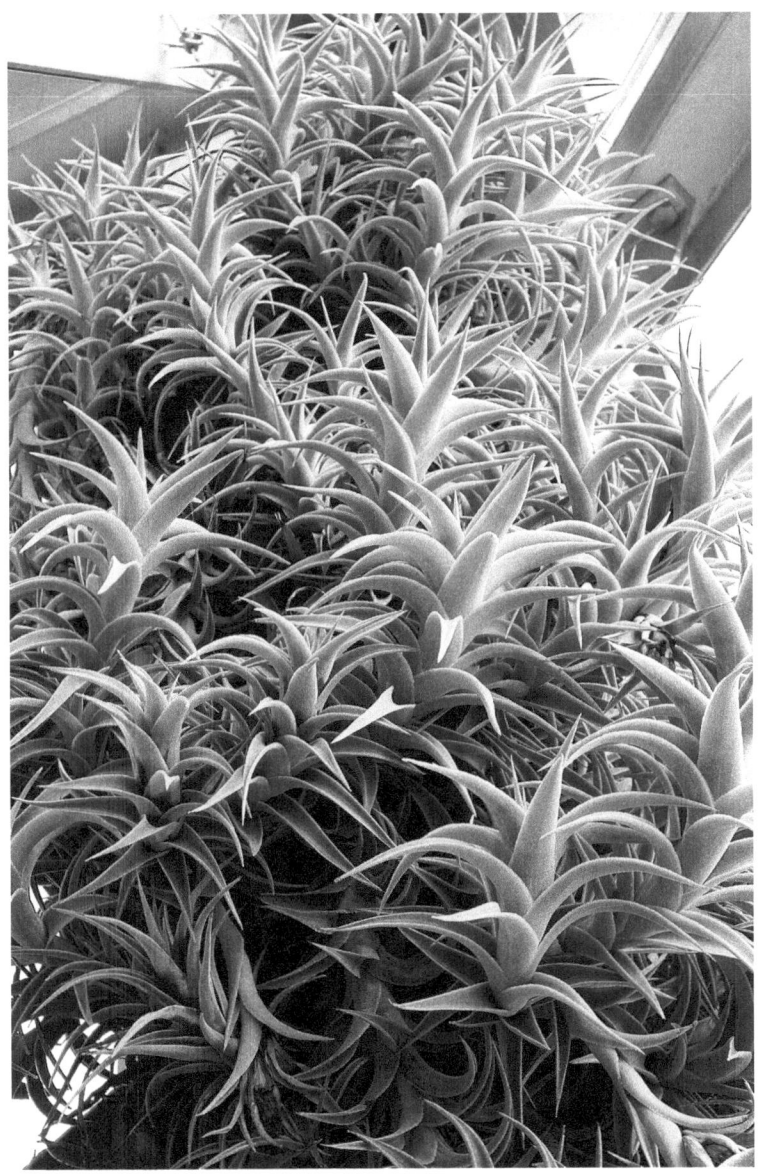
Succulent

SW DC Arts Festival

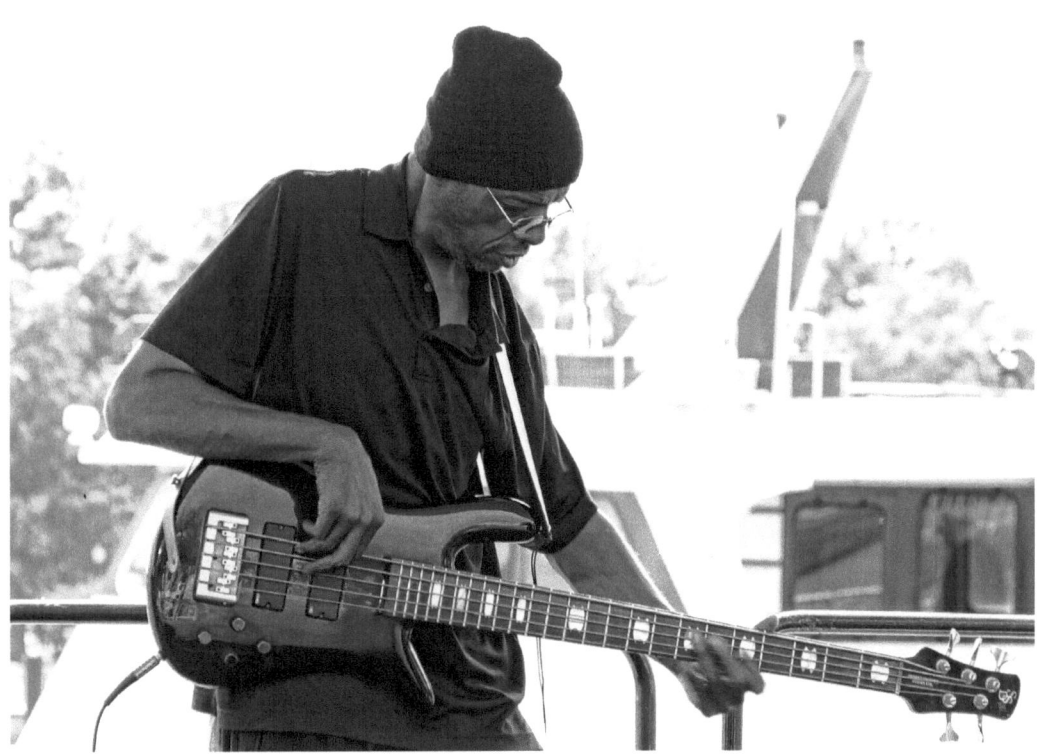

Bass Player

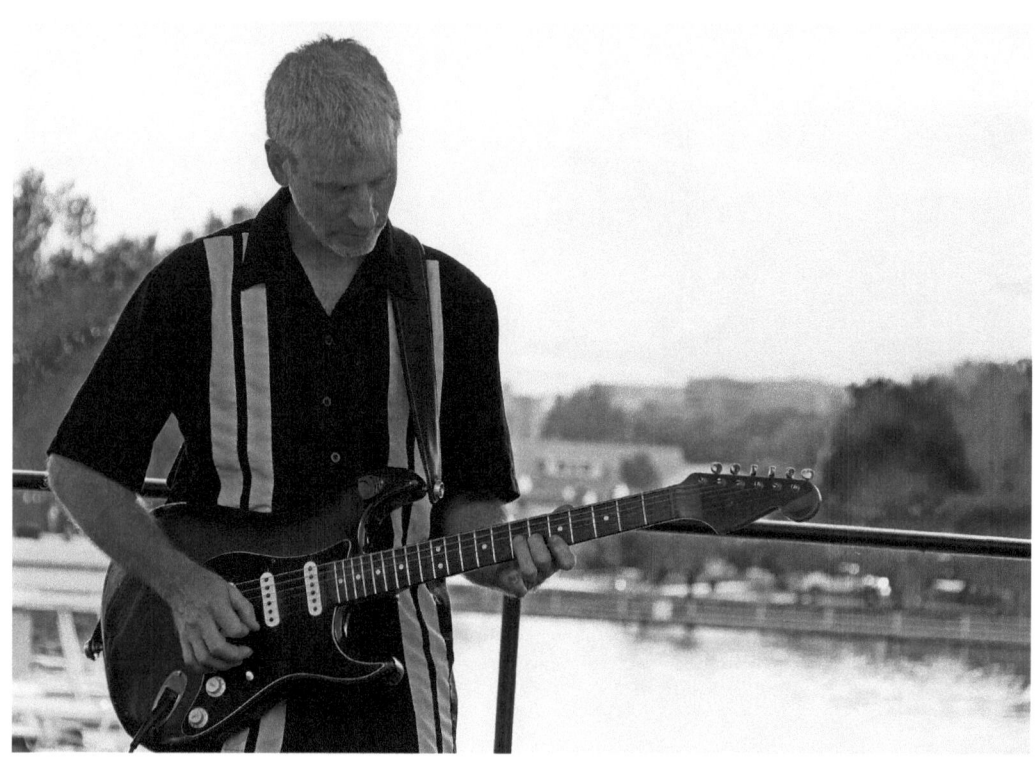

Guitar Player

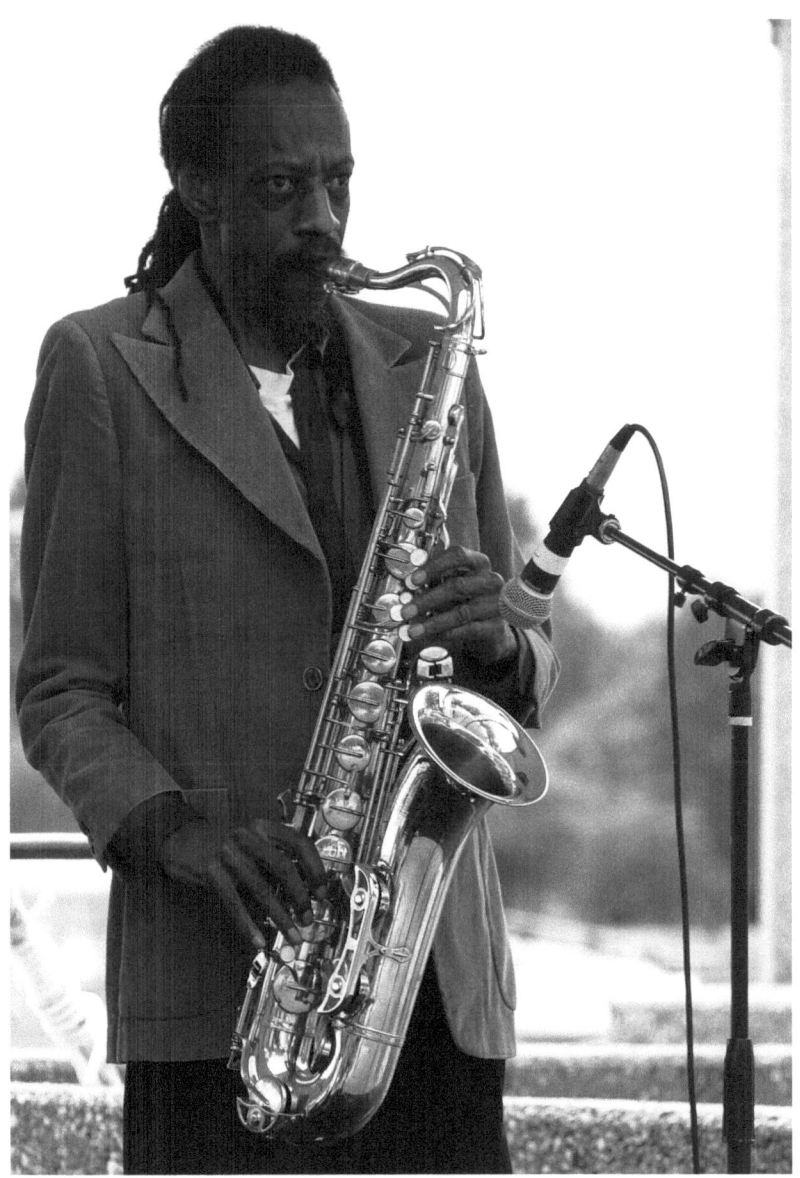

Sax Player

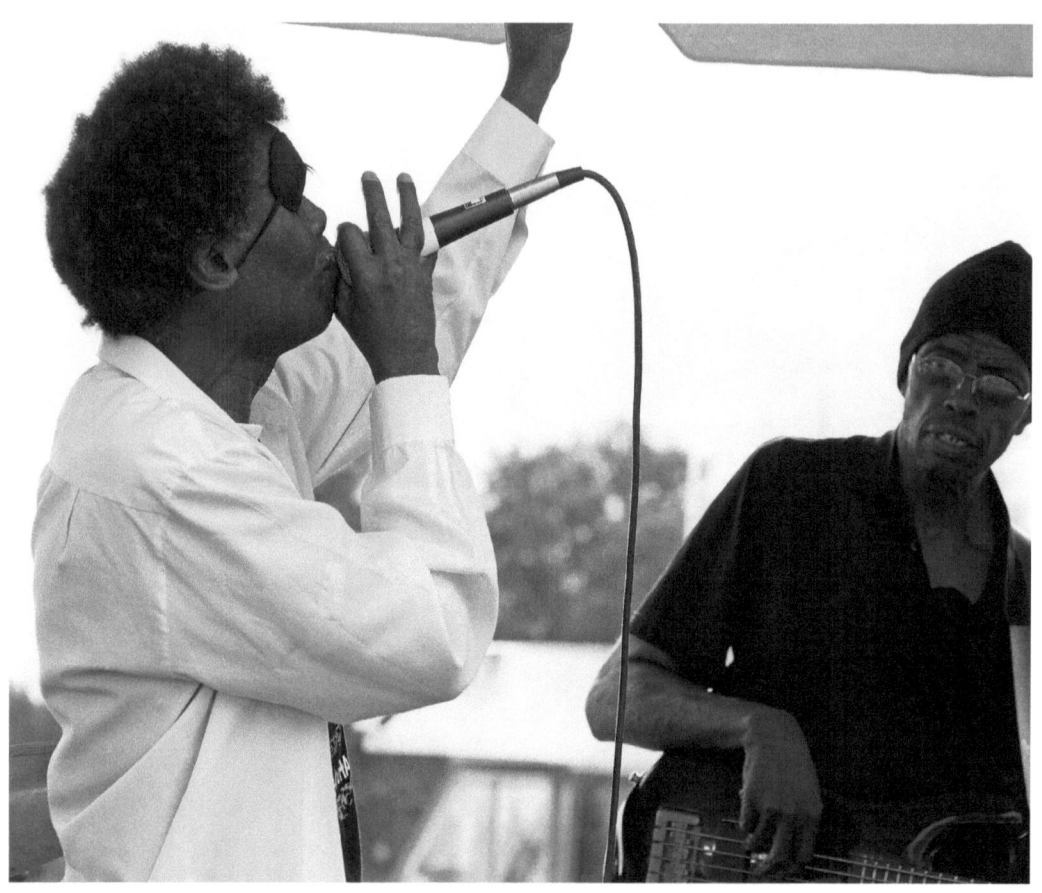

Bass Player and Singer

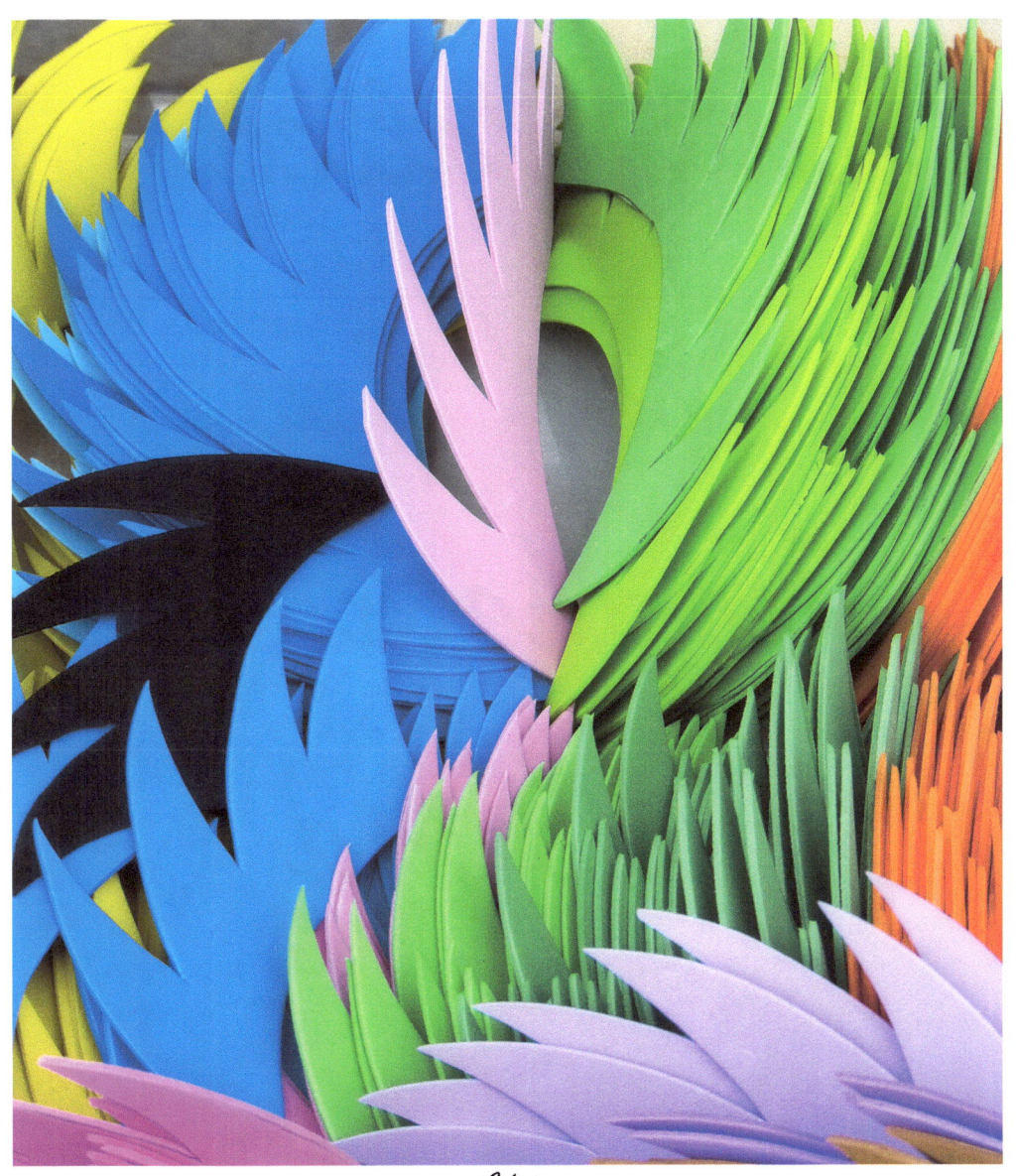

Colors

Death Valley and Northern California

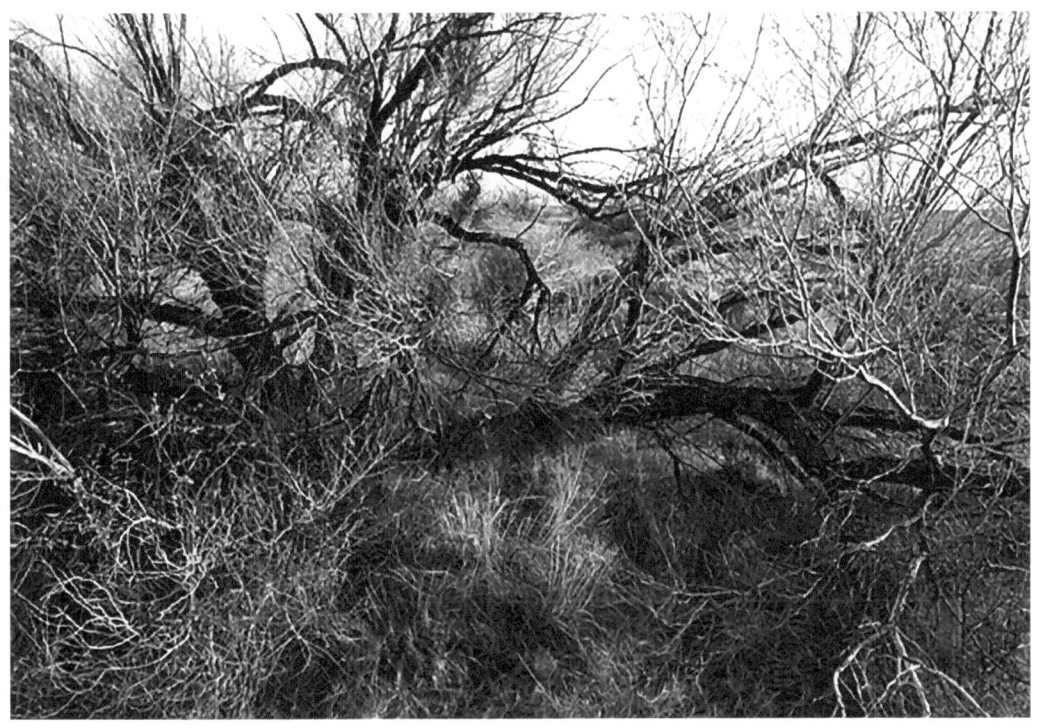

Bush

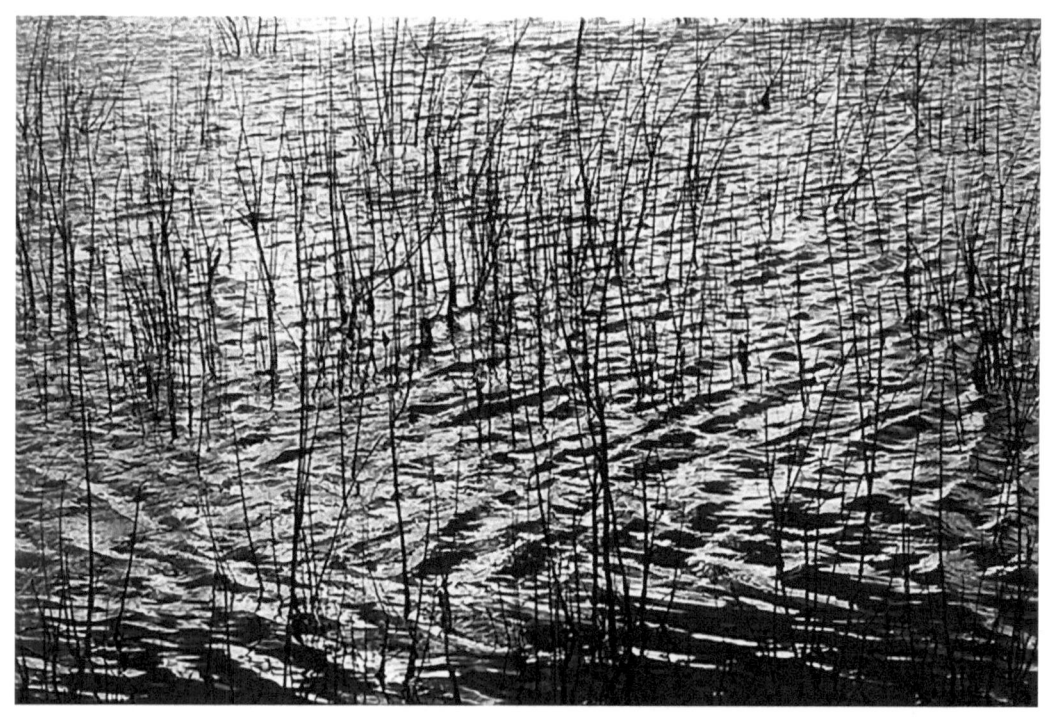

Reeds

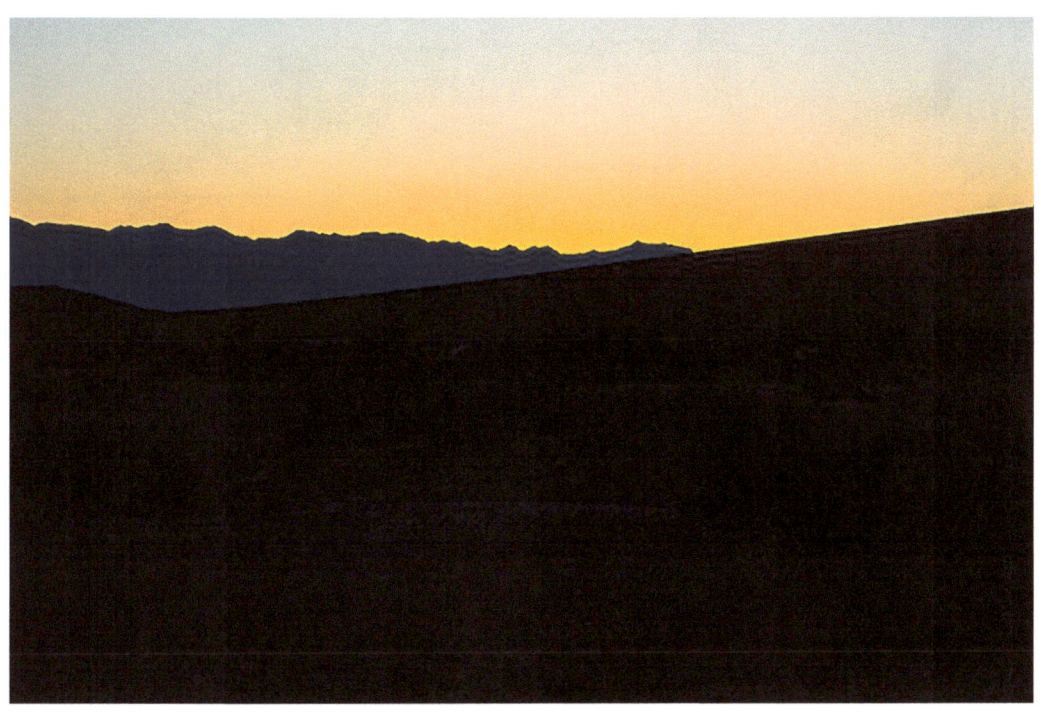

Sunrise, Death Valley

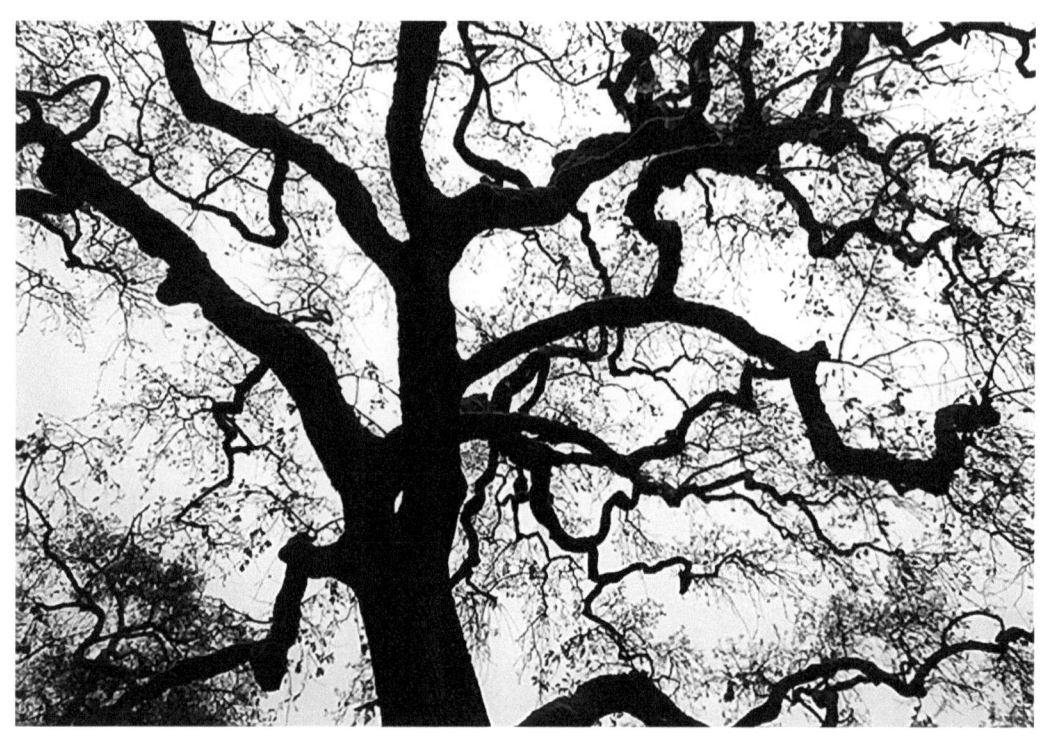

Tree, Napa California

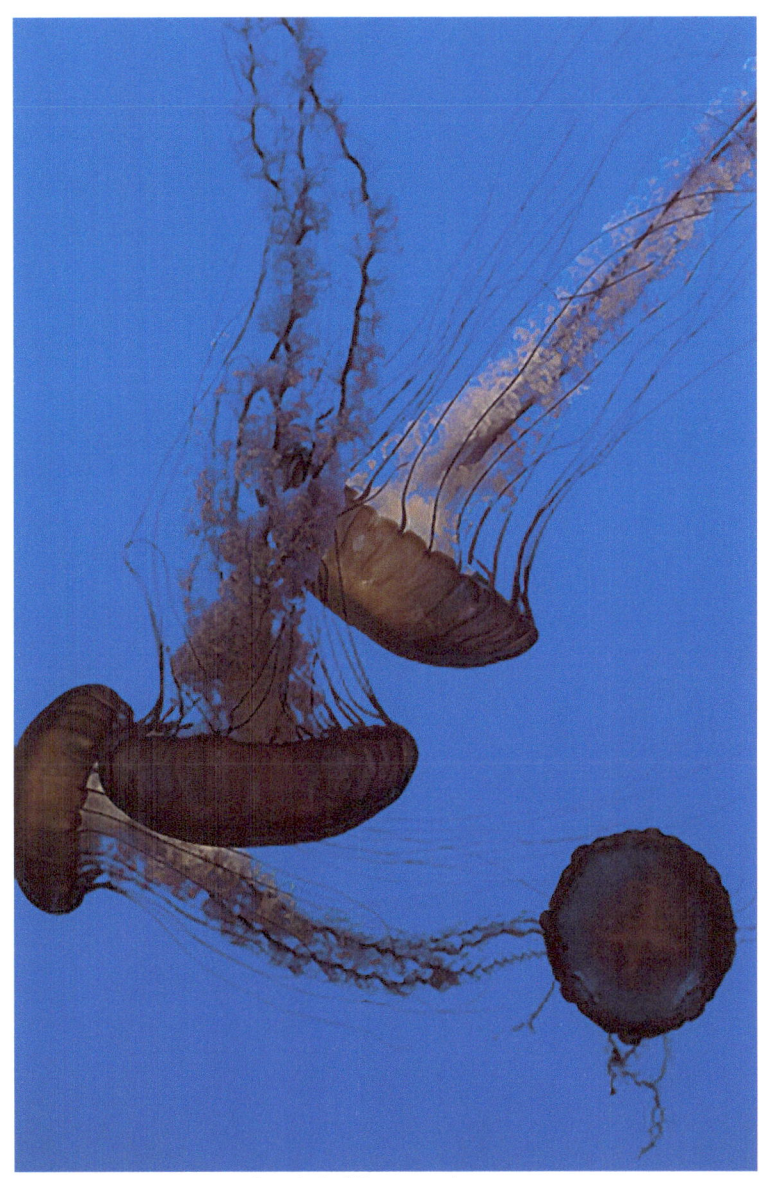

Jellyfish, Monterey Aquarium

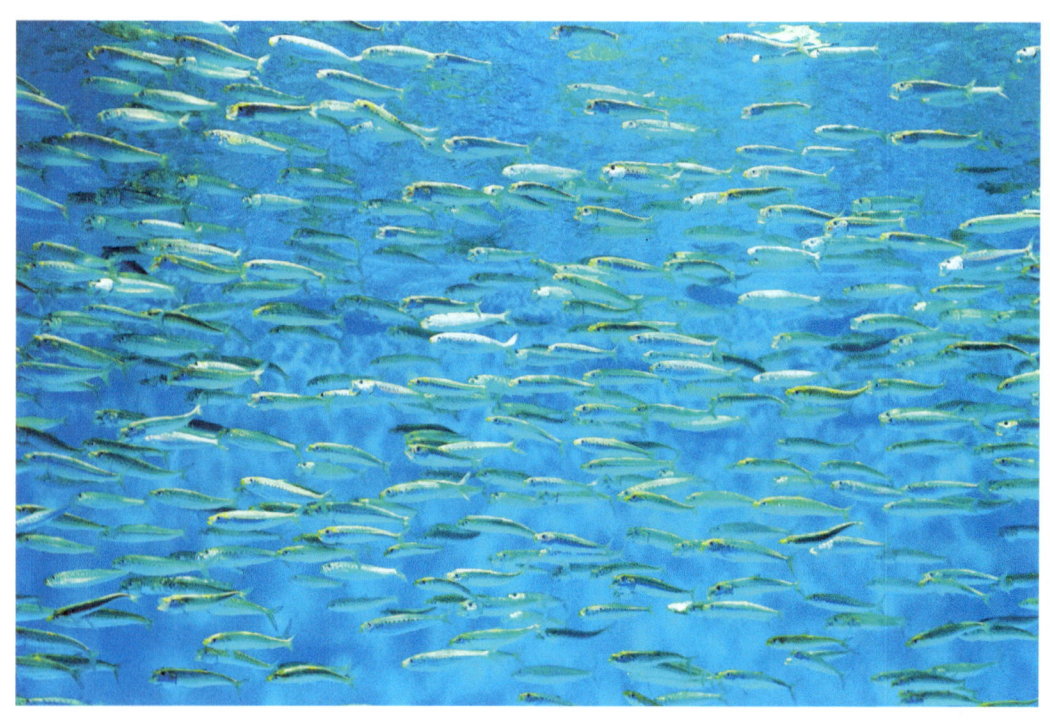

Fish, Monterey Aquarium

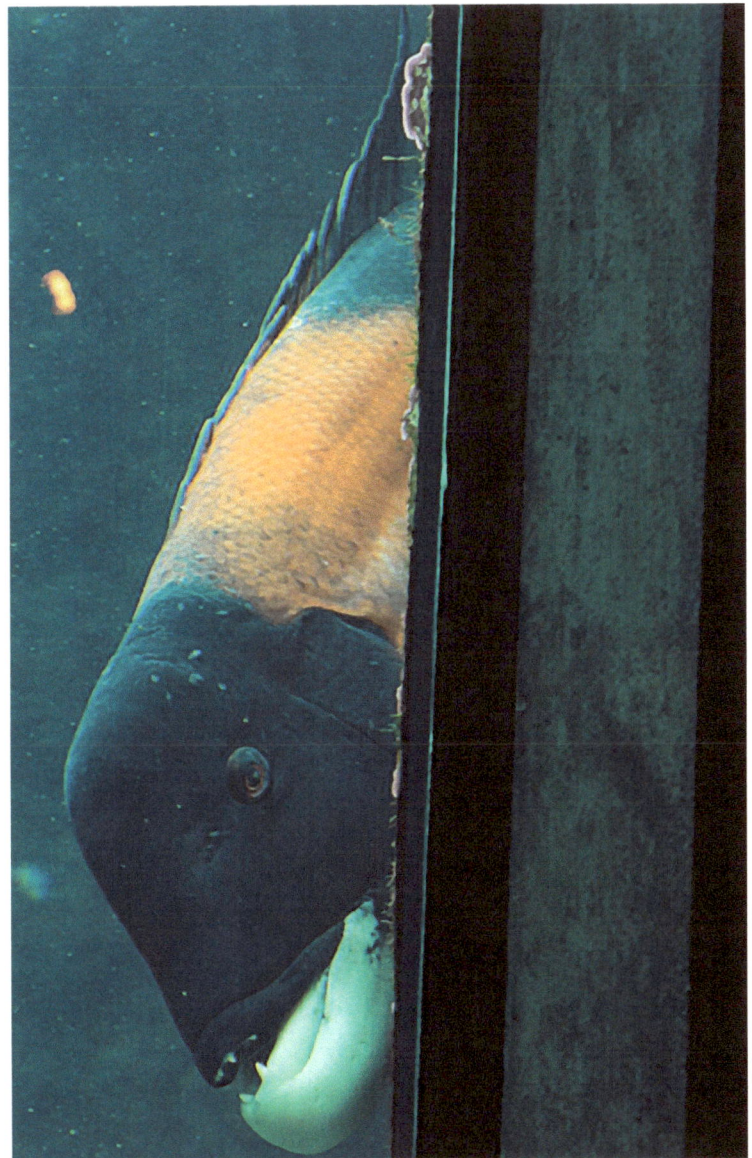

Fish, Monterey Aquarium

Other

Photos

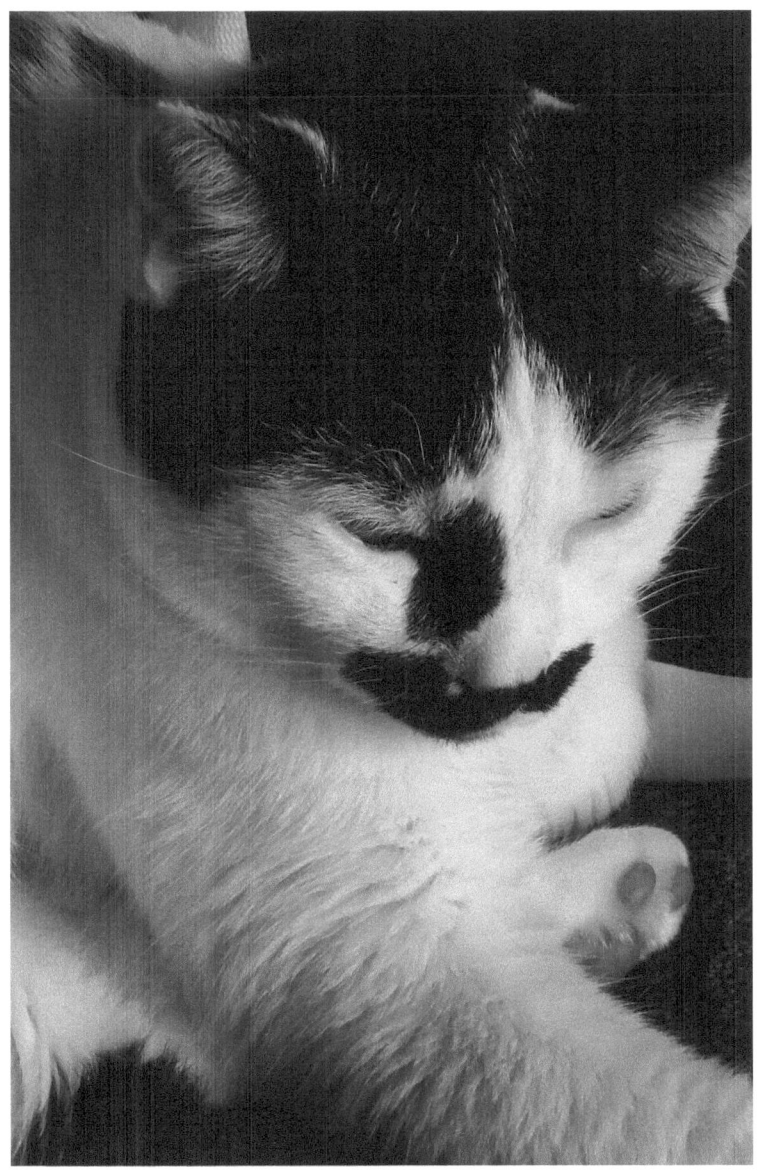
Frank

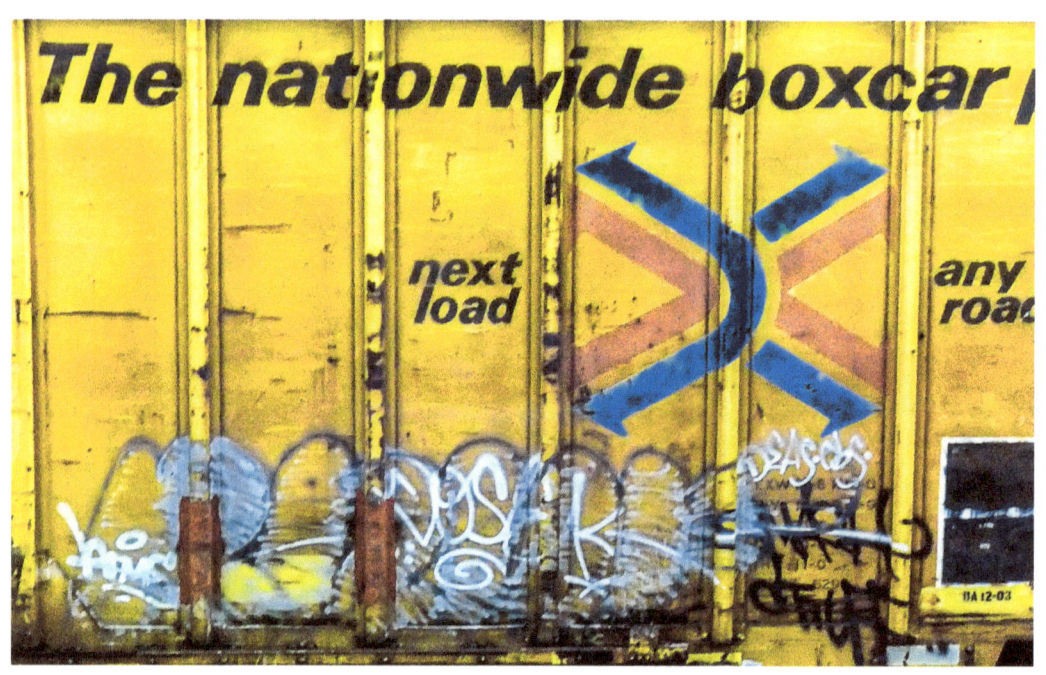

Boxcar

www.ingramcontent.com/pod-product-compliance
Lightning Source LLC
Chambersburg PA
CBHW050748180526
45159CB00003B/1387